IMAGES
of America

THE SCITUATE
RESERVOIR

*Enjoy the rest
of the story*

Ray Wolf

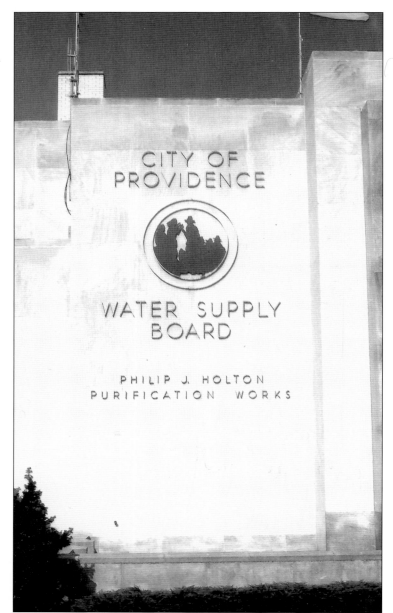

Philip J. Holton, the former chief engineer of the Water Supply Board, was recognized for the contribution he made for modernizing and improving the Providence Water Works. On May 23, 1969, Mayor Joseph A. Doorley Jr. paid tribute to him and rededicated it as the Philip J. Holton Water Purification Works. Taken March 17, 2010, this photograph is of the inscription on the front of the new Purification Works building. (Author's collection.)

ON THE COVER: The core trench of the Gainer Dam, also known as the Kent Dam, was excavated 100 feet below the Pawtuxet riverbed's elevation to solid rock. This photograph shows the foundation laid for the dam to be built on. Kent Village was in the area to the left, where its remains are now 87 feet under the Scituate Reservoir. (Providence Water Supply archives.)

IMAGES
of America

THE SCITUATE
RESERVOIR

Raymond A. Wolf

ARCADIA
PUBLISHING

Published by Arcadia Publishing
Charleston SC, Chicago IL, Portsmouth NH, San Francisco CA

Printed in the United States of America

Library of Congress Control Number: 2010927342

For all general information contact Arcadia Publishing at:
Telephone 843-853-2070
Fax 843-853-0044
E-mail sales@arcadiapublishing.com
For customer service and orders:
Toll-Free 1-888-313-2665

Visit us on the Internet at www.arcadiapublishing.com

*To my mom, Helen O. Larson, whose memory
inspired me to write this book*

CONTENTS

ACKNOWLEDGMENTS

The driving force behind this book becoming a reality is the memory of my mom. She lived in the village of Rockland until it was consumed by the building of the Scituate Reservoir. She told many stories of growing up there as a child. I also want to give Richard Blodgett from the City of Providence Water Supply Board a huge thank-you. He has again given many hours of his time on the phone and in person. The two of us again dug through the archives to obtain the photographs to complete this book. Because of his cheerful help, you are able to read this book. I also want to express my appreciation to Christopher Riely from Providence Water. Without his enthusiastic last minute assistance, I would not have made my deadline. Thank you, Chris. I wish to thank my friends Joe and Jenn Carnevale and Bill and Joyce Bartlett, along with family members Jake and Mona Cardente, for their tireless efforts proofreading and for being supportive and enthused about my endeavor. Thanks to my daughter, Ashlee Rae, for her patience and assistance in accompanying me on numerous trips to many locations. To Ramona, my wife and partner, for understanding and being patient with my passion to complete yet another book, I love you. I would also like to acknowledge the following people at Arcadia Publishing for all their help; Hilary Zusman, my assistant editor; Lynn Beahm, my publicity manager; and Beth McKenna, my senior regional sales manager. From my first e-mail inquiry of *The Lost Villages of Scituate*, through this companion book you hold in your hands, they never tired of my questions and were always encouraging and there for me, a great big thank you.

Unless otherwise noted, all images and maps appear courtesy of the City of Providence Water Supply Board archives.

INTRODUCTION

The year was 1911, and it was apparent the Pawtuxet River supply of water taken at Cranston was inadequate. The growth of Providence's population, coupled with dry periods, would soon put curtailments on water usage during peak periods.

On January 6, 1913, the city council appointed a Committee on Increased Water Supply. The committee, along with former city engineer Samuel M. Gray, was charged with investigating and recommending the best method of obtaining a sufficient supply of water. The committee exhausted all possibilities and submitted its report to the city council on February 21, 1914.

On April 28, 1914, a bill was brought before the House but died upon adjournment. On March 16, 1915, the city council again directed the city solicitor to apply for legislation to permit the city to develop an increased water supply. Chapter 1278 of the Public Laws of 1915 was approved April 21, 1915, and established the Water Supply Board. They were given authorization to acquire lands, estates, easements, rights, interests, and privileges that might be necessary by sale or condemnation using the power of eminent domain. The board was organized April 26, 1915, and B. Thomas Potter was elected as chairman.

The committee settled an agreement with the mills located below the proposed dam on the Pawtuxet River to release 70 million gallons of water a day to maintain their operation, as long as the reservoir was filled to capacity by the first day of June each year. Otherwise, the agreement allowed the flow to drop to 65 million gallons a day until full capacity was reached. The city council approved the condemnation plans December 4, 1916, and the plans were filed with the individual towns affected on December 6, 1916. At this time, the area contained over 2,000 buildings, which included homes, farms, mills, churches, stores, a police station, fire stations, and numerous other buildings and businesses.

The total area condemned equaled 14,800 acres and included the villages of Rockland, Ashland, South Scituate, Richmond, and Kent. It also included portions of North Scituate, Clayville, and Ponaganset Villages. By the end of December 1916, condemnation notices were being delivered to the residents in the villages affected.

There are six main bodies of water that make up the Scituate Reservoir system. First and foremost is the Scituate Reservoir, created by building the Gainer Dam on the Pawtuxet River. The second body of water is the Regulating Reservoir, which was made by creating the Horse Shoe Dam on the Moswansicut River. The Moswansicut Pond, Westconaugh, Barden, and Ponaganset Reservoirs all eventually flowed into the Pawtuxet and remain a vital part of the system. These six main bodies of water contain over 40 billion gallons when filled to capacity. The reservoir contains 28 small islands and has a flow line of approximately 38 miles long.

Helen O. Larson was born October 24, 1910, in the village of Rockland. She lived in the small New England village until she was 13, when she and her family were forced to move. Helen witnessed the destruction of her village and the heartache of her neighbors moving away one at a time. In the summer of 1923, when Helen was 12 years old, she wrote her first poem, "The Old School House," on the blackboard of her school as the workers were tearing it down. They could

not believe a 12-year-old girl was writing it. When Helen passed away in 2005, well into her 94th year, she had composed 1,700 poems. She believed she was God's instrument to hold the pen to the paper, from which ink would begin to flow. "I could never write like this with only an eighth grade education. People always say it's a gift I have," she often said.

<div align="center">

The Old School House
by Helen O. Larson
</div>

It was a very sad day
When we were told
They were building a reservoir
And our school would be sold

A man came one day
Nailed up a sign for all to see
The sign read "condemned"
It meant heartbreak for me

It was then we were told
An auctioneer would come one day
To auction off the old school house
To be torn down and taken away

Then the day arrived
The auction took place
The people began to bid
Tears rolled down my face

Going, going, gone
The auctioneer cried
And on that fateful day
Something within me died

The old school house at Rockland
Now is used no more
We hear no more footsteps
Walk across the floor

I'll come back now and then
To reminisce and see
But the old school house at Rockland
Will be just a memory.

One

CREATING A NEW RESTING PLACE

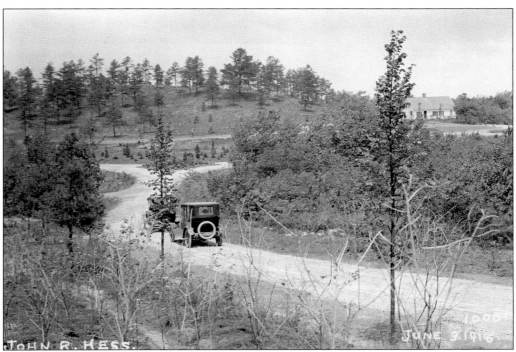

On July 23, 1917, preparation began on the New Rockland Cemetery. This photograph, taken June 3, 1918, shows the city checking the site out before almost 1,500 bodies started arriving September 14, 1918. The Town of Scituate declined to accept the cemetery plan submitted on September 19, 1918; therefore, the maintenance of it has continued to be the obligation of the Water Supply Board.

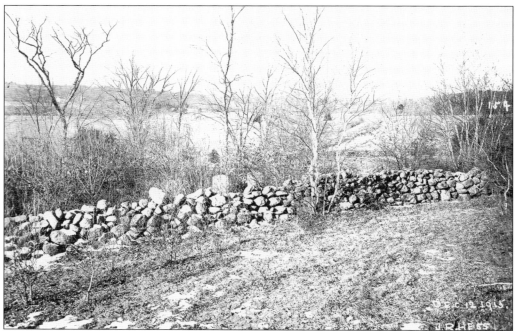

John R. Hess was hired by the City of Providence to photograph all existing burial grounds within the limits of the planned reservoir, whether they were too be exhumed or not. Located east of the North Scituate to Kent Road, just outside of Kent, Lillian V. Searle owned the site of this plot.

This photograph, taken on December 12, 1915, was located on the south side of Bald Hill Road, east of Kent. The property belonged to F. B. Hutchins. On the right, the round-top headstone reads as follows: "John Graves / Born April 9, 1787 / Died October 31, 1865 / Aged 78 years, 6 months, / and 22 days." The one on the left reads, "Anna R. / wife of / John Graves / Died June 29, 1871 / Aged 84 years / and 29 days."

The headstone on the left reads, "In memory of / Capt. Ezra Knight / who died October 11, 1812 / Aged 78 years, 1 month, / and 4 days." The one to the right states "In memory of / Rhoda Knight / wife of / Capt. Ezra Knight / who died"; unfortunately, the grass blocks the rest of Rhoda's tombstone's engraving. Lyman A. Knight owned this property on the south side of the Kent to Coventry Road when this photograph was taken December 12, 1915.

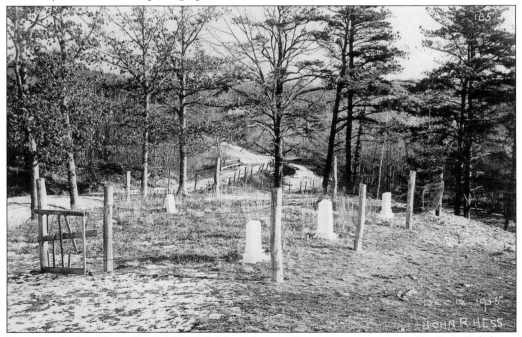

Photographed on December 12, 1915, this burial ground was on property owned by E. A. Salisbury. Located near the Knight Brook, visitors could peacefully watch from the west side of Young's Road the occasional car that would pass from time to time.

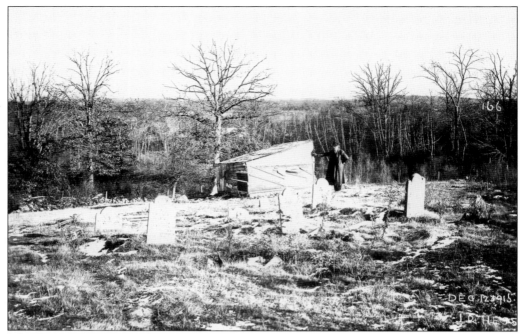

John R. Hess continues photographing plots on this sunny but cold December 12, 1915. This one is on land owned by Susan D. Walker, located on the west side of Young's Road. The only engraving readable was on the large stone to the left that reads, "In Memory of Sarah."

D. E. and A. B. Young owned these 30.5 acres with 1,796 feet of frontage on the east side of Young's Road. The back side of their property ran along the Pawtuxet River and was doomed in the name of progress. This cemetery commanded the center of their parcel of land.

Hess found this all but forgotten burial ground on Henry C. Barden's property. His 55-acre parcel ran along the Ponaganset River and was totally consumed by the reservoir. It was located on the Richmond to Rockland Road at the junction of River View Cross Road.

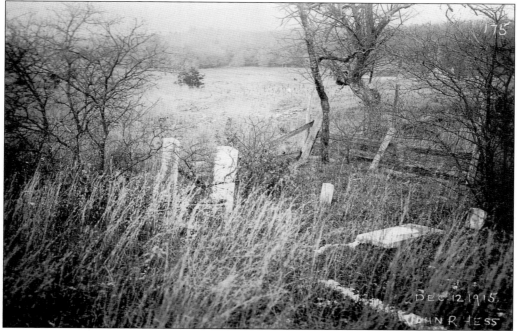

Wilbur Hollow Road traveled south and ended at Plainfield Pike. If travelers turned west and went 200 feet, they would be in front of Henry M. Schmidt's 4-acre homestead. It was positioned on the north side of the Pike, and at the very northwest corner was this uncared for burial ground.

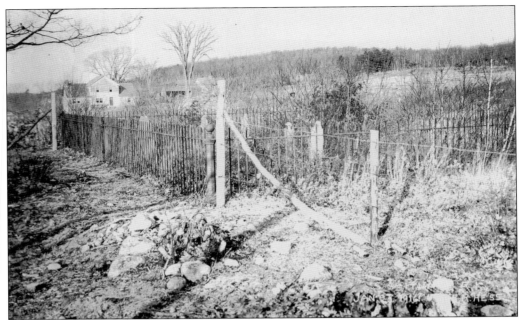

Mary E. Wilbur owned this 24-acre parcel. Her property had 1,440 feet of frontage on the west side of North Scituate to Kent Road and 996 feet on the south side of Plainfield Pike. The back of her property ran along the Moswansicut River. Her farm can be seen in this photograph, taken on Tuesday, January 25, 1916.

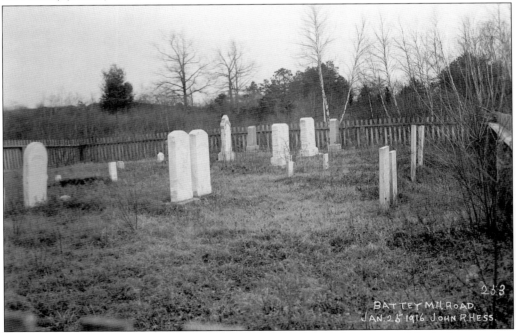

This burial ground resided on Fred Longbottom's 75-acre farm. It was one of the lucky ones that did not need to be removed, as it was on the west side of Battey Meeting House Road. Fred's farm was taken because it was in the watershed area. This photograph was taken January 25, 1916.

14

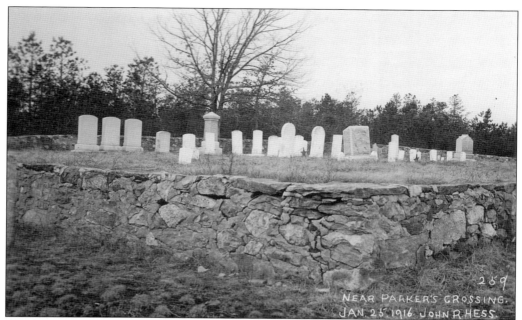

Charles Parker and his family lived on this 94-acre farm. Their home and barns were located on the south side of Parker's Crossing Road, and the farm ran all the way down to the east side of Battey Meeting House Road and is therefore submerged. The Providence and Danielson Railway ran through the property on its way to Ashland and traveled within 30 feet of the family cemetery.

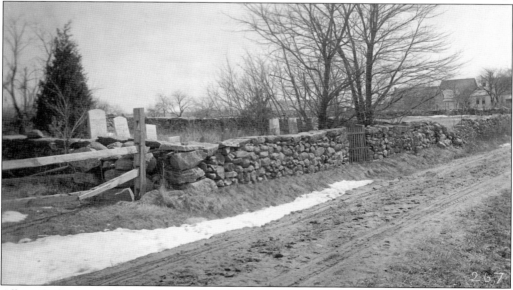

Albert C. Potter and his family owned the 85-acre parcel this burial ground rested on. The road passing it was the Clarke Potter Road, now known as North Road or Route 116. Two sides of their farm bordered the Quampaug Brook, which would flow into the reservoir; therefore, the farm was taken. When traveling Route 116, one should stop at this cemetery, climb over the wall, and visit at the small stone in the front right corner of "Andrew Harris / Captain RI Militia / Revolutionary War."

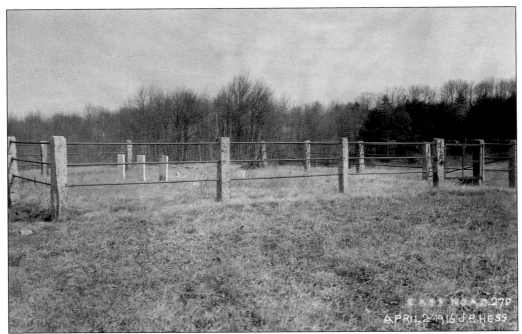

The Quampaug Brook flowed through Stephen B. Randall's 42 acres and emptied into the Moswansicut River. This cemetery on Stephen's property was on the west side of North Scituate to Kent Road, just north of Byron Randall Road. Hess took this photograph on April 2, 1916.

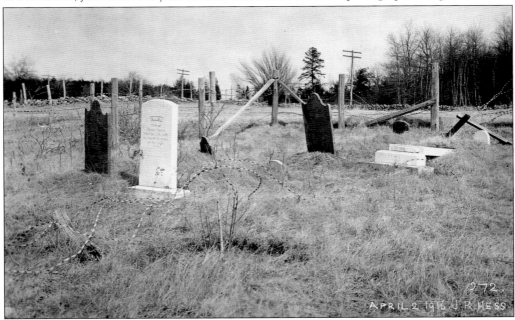

The white headstone states, "Ellen / wife of / Abner Pratt / died December 26, 1851 / in the 86th year / of her age." She was interred on Charles C. Hall's 18 acres on the west side of North Scituate to Kent Road. On pages 36 and 37 in the companion book, *The Lost Villages of Scituate*, one can view his beautiful home on 51 acres across the road, overlooking the Moswansicut River.

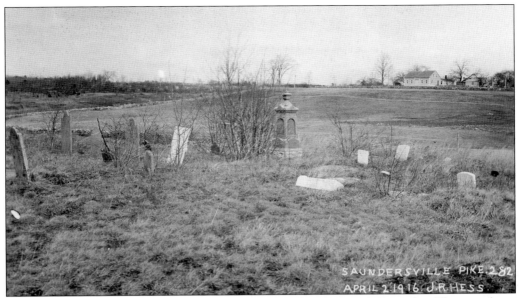

This burial ground was in the northwest corner of Fred E. Coppage's 5-acre lot. The parcel was situated at the corner of Saundersville Pike and North Scituate to Kent Road. Hess continues his assignment of photographing all the burial grounds on Sunday, April 2, 1916.

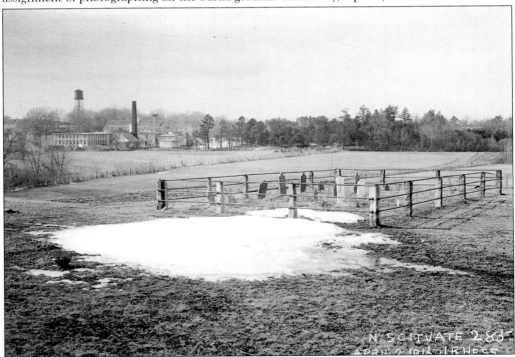

This neatly guarded cemetery was on a parcel of land owned by Edward P. and Cynthia A. Harris. The 33 acres were on the west side of North Scituate to Kent Road, a little south of Danielson Pike. This area, as well as the North Scituate Cotton Mills in the distance, is now beneath the reservoir.

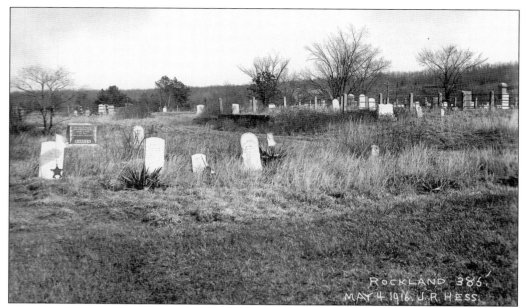

This photograph, taken May 4, 1916, is of a portion of the Old Rockland Cemetery. The headstone in the foreground to the far left is announcing Henry Randall's resting place. The next one to the right reads, "Susan A. / daughter of / Henry and Mary A. / Randall / died in her 18th year." The little one reads, "Lydia J. / daughter of / Henry and Mary A. / Randall," and the next one states, "Albert H. Randall / Died 1873 / Aged 12 years, 8 months, / and 11 days."

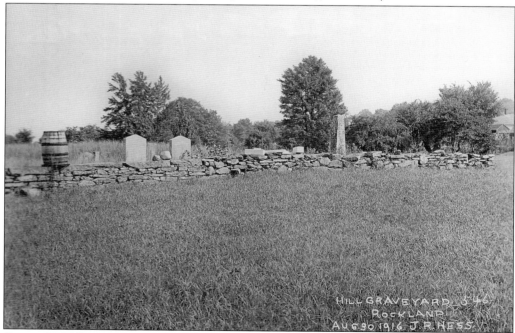

George E. Hill owned 38 acres behind the Rockland Mill with access from the Rockland to Richmond Road. The grass has taken over this graveyard, as it seems those interred have been forgotten. Hess is still recording history on this sunny Wednesday, August 30, 1916.

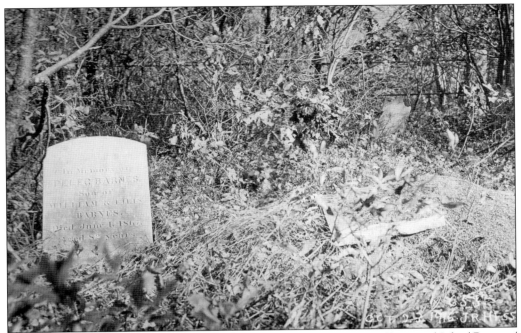

This gravestone announces, "In memory of / Peleg Barnes / son of / William and Lilis / Barnes / Died June 1, 1867 / Aged 82 years." This lone grave was on Edward F. Page's 135-acre farm, which included a 4-acre pond. This was photographed on October 23, 1916, during Hess's travels.

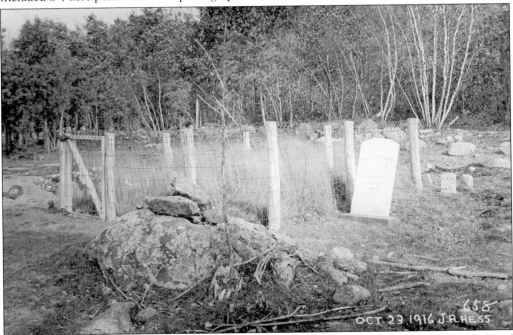

Mary E. Wilbur also owned a 5-acre lot at the junction of North Scituate to Kent Road and Plainfield Pike. It contained this burial ground with a headstone that reads, "Duty S. Hopkins / Died October 25, / 1865 / in the 81st year / of his age / Jesus is my resting place."

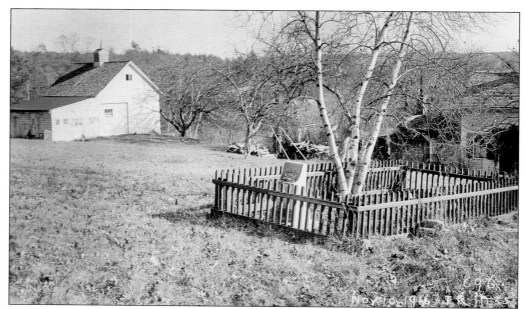

Frances J. Esleeck owned 6 acres on the north side of Plainfield Pike, just outside and east of Wilbur Hollow. It seems that he had a nice barn with his house to the right. Directly behind his house is a small fenced in area with three birch trees and a large headstone. The only inscription that can be read is "Mother." There is also a small stone behind the birches. This photograph was taken on a sunny Tuesday, November 10, 1916.

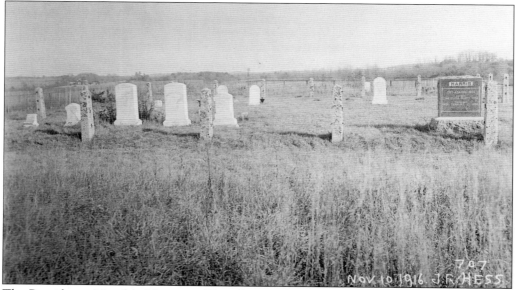

The Providence Monthly Meeting of Friends owned a small lot, under an acre, on the north side of the Road to Elmdale at the junction of Elmdale Cross Road. The dark tombstone to the right reads as follows: "Harris / 1783-Asahel-1850 / His wife / 1798-Eliza Olney-1861 / Their Daughter / 1836-Caroline-1850." Eliza was 15 years younger than Asahel and lost him and their 14-year-old daughter the same year. It must have been heart breaking; nevertheless, she carried on for another 11 years.

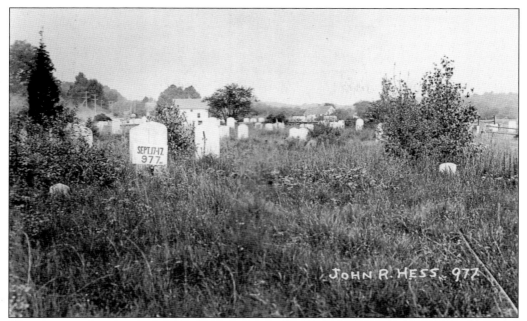

This photograph, taken by John R. Hess on September 17, 1917, shows a section of the Rockland Cemetery that needed to have those interred moved. The telephone poles, which are visible in the upper left, are running down the side of the Rockland to Richmond Road, which leads to Rockland Village.

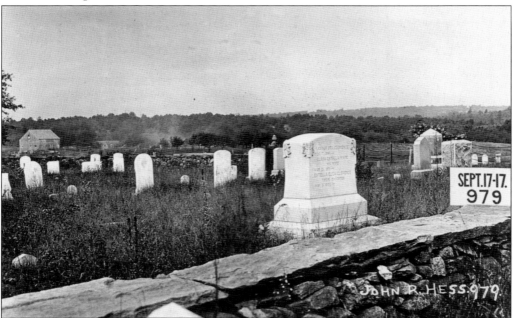

This is another view of the Rockland Cemetery. It appears someone was planning ahead when this huge headstone was erected. It reads as follows: "Lester Ora Clemence / December 7, 1861– / Clara Estella Wade / His Wife / March 21, 1871– / Estella Eliza Clemence / Their Daughter / May 3, 1902–." Evidently, no one was deceased at the time. Hess is out again working on this Sunday.

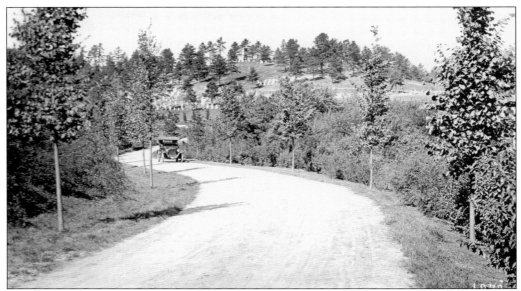

As a city official is leaving on the entrance drive, a portion of the New Rockland Cemetery is displayed in the distance. This photograph, taken on September 26, 1919, is looking in a northerly direction.

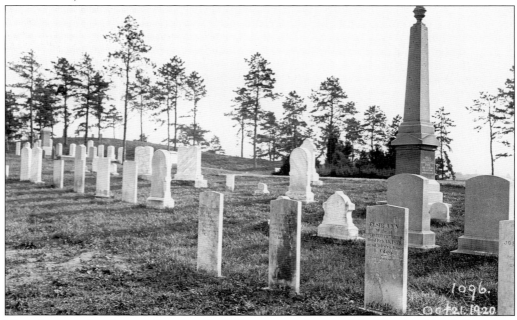

This photograph, taken on October 21, 1920, is a typical view of the New Rockland Cemetery, showing parts of sections U, V, and W. The three headstones in the foreground can also be seen on page 13 in the bottom photograph. The one to the right reads, "Elsie Ann / Wife of / Sylvester Patterson / Died February 15, 1856 / Aged 29 years, 4 months, / and 4 days." The one in the middle states, "Clemence / Wife of / Codolphin Patterson / Died August 31, 1849 / In the 73 year / of her age." The third one says, "Codolhphin Patterson / Died / February 24, 1859 / In the 81 year / of his age."

Two

CREATING NEW ROADS

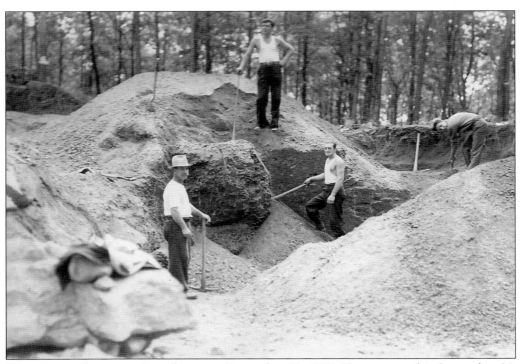

Water began flowing to Providence on September 30, 1926. However, as this September 24, 1936, photograph shows, work was still being done on city property. It shows four men digging disintegrated rock with picks and shovels on the lower bank of Blackmar's Lane. Although the 26 miles of roads that replaced the 36 that were abandoned had already been completed, work continued to be done on fire lanes throughout the property.

This view was photographed on June 8, 1916, and shows the Big Oak Farm. The oak shaded Alma M. Paine's home on the Ashland to Ponaganset Road for many years. The road needed to be reconstructed in order to replace the Old Plainfield Pike, which would soon be underwater.

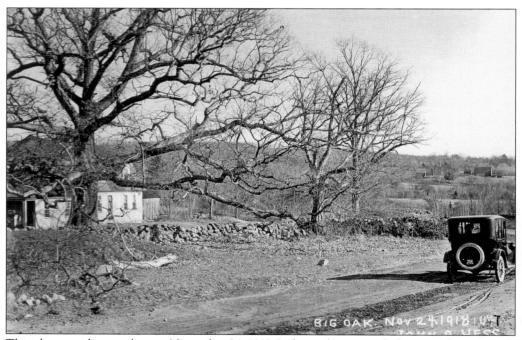

This photograph was taken on November 24, 1918. It shows that instead of cutting down the oak during reconstruction they decided to divert the road to the right. After an estimated 250 years, "Big Oak" finally succumbed to a slow and painful death by fire and vandalism in the 1980s.

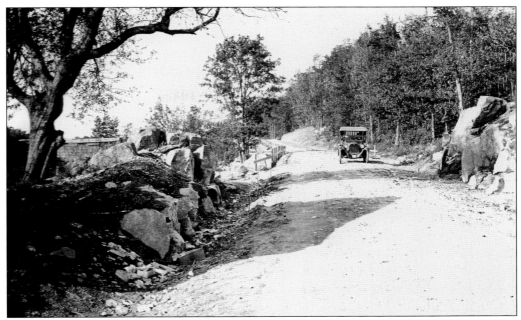

This photograph of the East Road (Route 116) is just after the junction of Bald Hill Road. This would be just north of the new Scituate Avenue and Route 116 intersection. As one travels north, the dike is on the left, along with a view of the reservoir. The 30.76 acres on the left was taken from the Sarah A. Roger's Estate, and the 10.63 acres on the right belonged to John B. W. Greene.

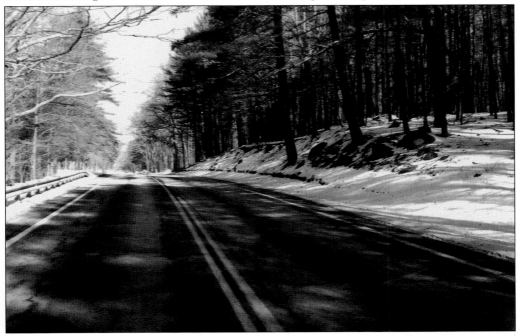

This photograph of Route 116 was taken January 2010, looking northerly. It is the same area pictured behind the automobile in the above picture. At the end of the guardrail on the left is the gate to the dike—one of the few areas where the reservoir comes close to the road. (Author's collection.)

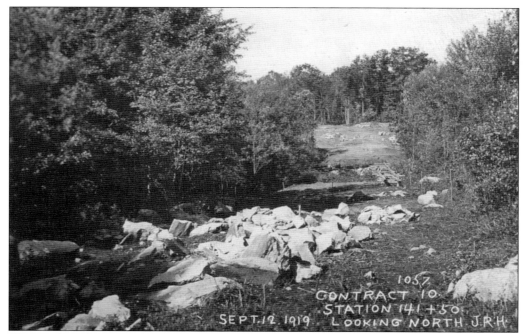

This road was being constructed on property taken from Charles C. Hall. Because it was east of the reservoir, it was called the East Road. Over the years, it became the North Road, since it leads from Hope to North Scituate Village. People traveling through today know it as Route 116.

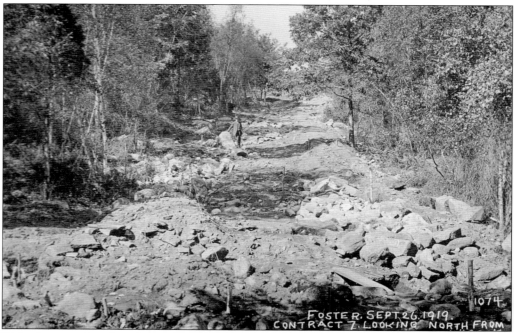

This photograph, taken September 26, 1919, was of the relocation of Plainfield Pike in Foster. It is looking in a northerly direction and shows boulders and the general rough character of the country.

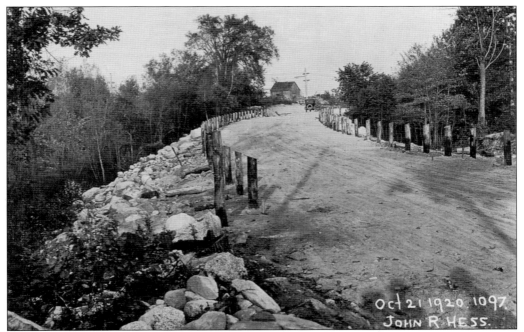

John Hess took this photograph in the early morning of Thursday, October 21, 1920. This is the relocated Plainfield Pike in the town of Foster, heading northerly into the village of Clayville. It is showing the road near completion.

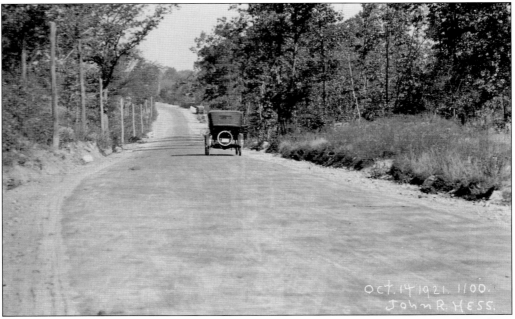

On October 14, 1921, a year had past, and Hess continued photographing history in the making on this sunny Friday morning. This view is looking northerly from the junction of Briggs Road in the town of Foster. As Briggs Road turned west at this point, Plainfield Pike turned south through Walter Dunham's property.

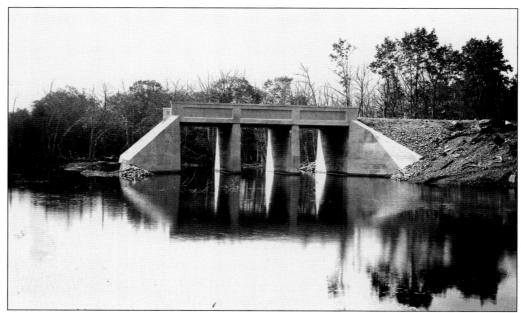

These two photographs from August 14, 1922, demonstrate that construction of roads and the bridge is progressing. In three short years, the dam will be complete, and the water will start rising. They illustrate a very interesting concept. Instead of building a bridge across the Ponaganset River, this bridge was built to the middle of the river, and then, as shown in the bottom photograph, trucks kept backing up and dumping gravel on the west side until the fill reached all the way to the bridge. This forced the river to flow under the newly constructed bridge. Both of these views are looking northerly from the south side of Shoddy Mill Pond.

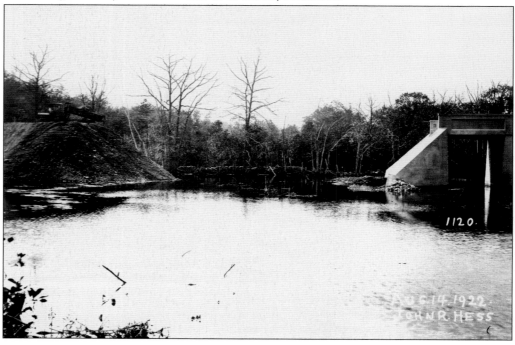

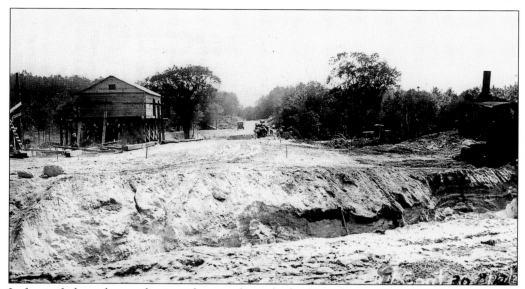

In front of where the purification plant was being built, this is the new East Road, looking south. The purification plant is being constructed to the left but is not pictured. The pipeline leading to it from the bottom of the dam had been laid under the roadway at this point. The building shown is the contractor's cement shed.

This photograph, taken in January 2010, was taken from the same location as the photograph above. The mound of dirt on the right is covering the pipeline as it travels below Route 116. The purification plant entrance can be seen on the left. When traveling this roadway, think of the water underneath that is flowing 24 hours a day, seven days a week to supply 60 percent of Rhode Islanders with the second-purest water in the country. (Author's collection.)

This photograph of the construction of the new East Road was taken on September 28, 1924. This is looking northerly where it briefly joins Betty Pond Road. Today Betty Pond Road heads off to the right through the woods on its way to Plainfield Pike.

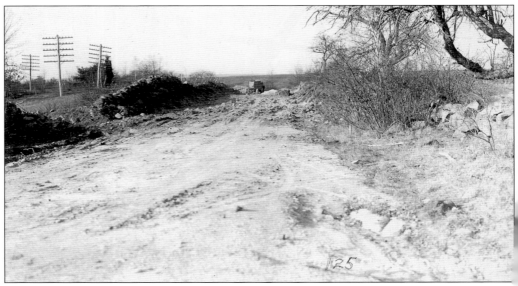

This photograph, taken on December 11, 1925, shows the rough grading of Bald Hill Road, known today as Scituate Avenue or Route 12. This is just before it travels down the hill and across the new East Road on its way to the village of Kent, which is now beneath 87 feet of water.

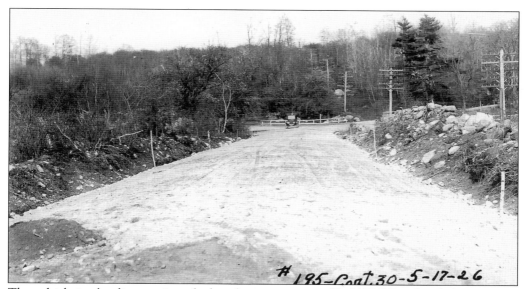

#195-Cont.30-5-17-26

The vehicle in the distance is parked at the intersection of Bald Hill Road and the new East Road. Bald Hill Road bears off to the right and up the hill, which can be seen on the opposite page. As Bald Hill Road headed west, it had to be diverted so it would follow the dike until it joined the road crossing the dam.

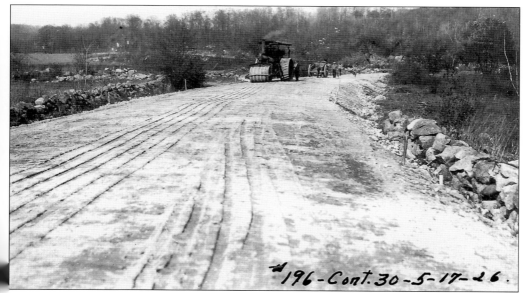

#196-Cont.30-5-17-26.

A little further west toward the dam, this is the Bald Hill Road connection. The dike can be seen in the upper left area. The steam roller is packing down the gravel. For security purposes, Providence City Water barricaded this road after 9/11. In 1963, this road was replaced with a more direct route to the new Scituate Avenue. When this photograph was taken, the reservoir was about half filled.

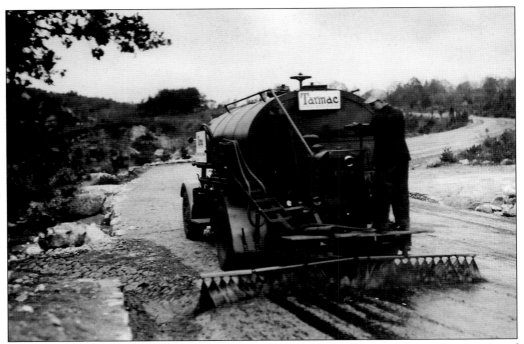

Although the reservoir had been sending water to Providence for almost ten years, construction of fire lanes was still in progress on October 28, 1936, when this photograph was taken. It also shows the great progress made in the evolution of equipment. This truck is applying an oil application to the gravel base, as it heads west on Knight Brook Lane to East Road.

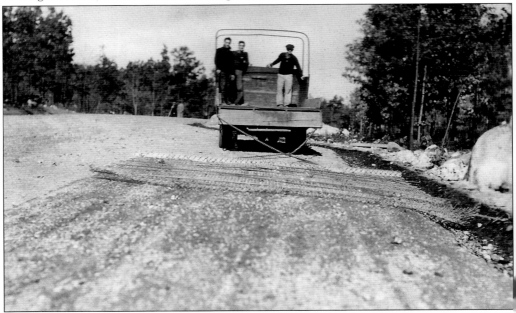

This view of Knight Brook Lane is looking easterly. A thin coat of sand was applied over the oil, followed by a truck that dragged a chain-link screen over it to create a tar road. This photograph was also taken on October 28, 1936.

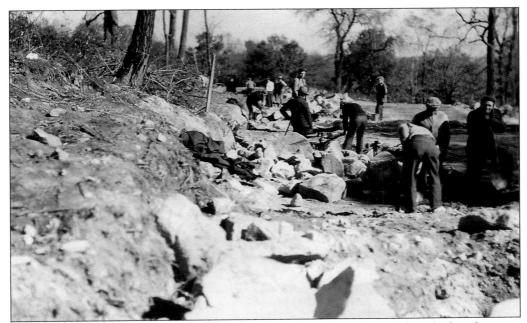

Many sections of the Old Tunk Hill Road had to be reconstructed and raised to a higher elevation, because many parts of the old road were going to be submerged under the reservoir. In this photograph, taken Wednesday, October 28, 1936, men are hard at work on this section, which is looking southerly.

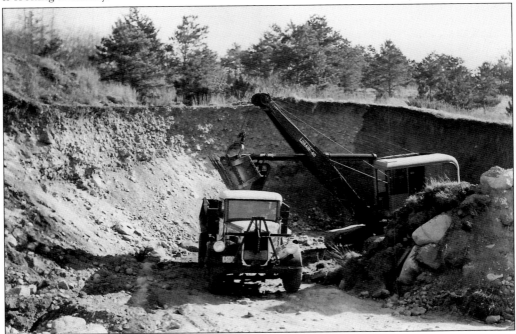

On February 4, 1937, they are still digging in the Battey Meeting House Gravel Bank. It is located at Saundersville Pike. This truck, license plate number A 569, is waiting to be loaded by the Lorain-40 steam shovel. The gravel was used in construction of parts of the 26 miles of new roads.

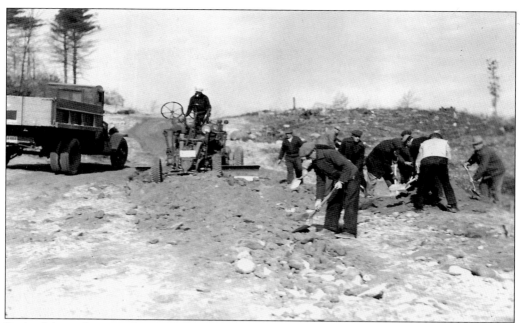

Both of these photographs were taken on Saturday, February 20, 1937. In the one above, men are working with the Road Hog Grader in operation. The location is Battey Meeting House Road, and once it was graded, the roller, pictured below, would pack the gravel to ready it for the oil and sand process. As a point of interest, due to the United State's declaration of war against Germany on April 6, 1917, there was a shortage of manpower. The Water Supply Board deemed it necessary, and wise, to slow work down. Progress would not pick up again until May 16, 1919, when work resumed on the Gainer Dam by the Sperry Engineering Company of New Haven, Connecticut.

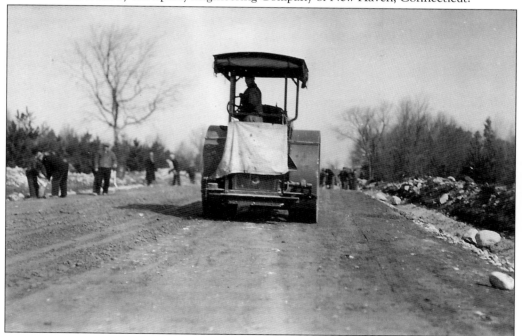

This photograph, taken May 17, 1937, is of Battey Meeting House Road, looking south with the gate at the end. The relocated Plainfield Pike is shown leaving the Ashland Causeway, headed west towards Rockland. The seal coat has already been applied to this section of roadway. The following verse is from "I Left My Heart in Rockland" by Helen O. Larson: "I can't forget the place where I lived for years / And if I dwell on it very long I may be close to tears."

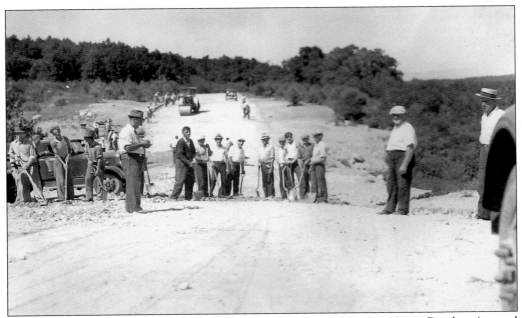

On July 15, 1937, these workers are manually grading Battey Meeting House Road at Atwood Causeway. This photograph is looking north, and the roller can be seen in the distance. It appears the workforce stopped working with their shovels long enough to have their picture taken.

The photograph above, taken August 3, 1937, is looking northerly with the completed Gainer Dam as a backdrop. In the lower left corner is Nursery Road, approaching the access road and traveling from below the dam east to the purification plant. The man in the center is surveying for the future repair of Nursery Road, as shown below completed on October 1, 1937. Nursery Road was where the fields were located to grow five million pine seedlings for reforestation around the reservoir between 1935 and 1942. Two million had been purchased from various nurseries in Canada and New England. Unfortunately, these pine seedlings were found to be too expensive and they also had a low survival rate.

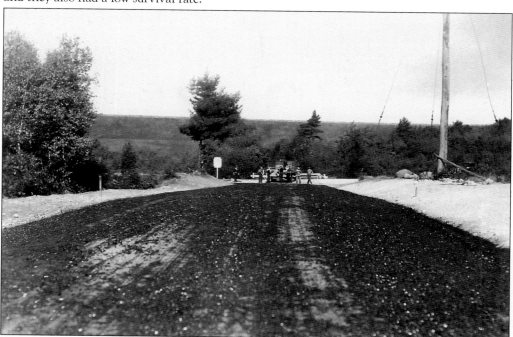

This photograph, taken on March 7, 1938, shows the process of thinning and burning the under brush, which is performed before planting the pines. Planting crews were given two weeks or more of instructions of proper planting methods. This view is from the new East Road (Route 116), looking west. It is just south of Waterman's Four Corners where Elisha A. Waterman resided. The photograph below was taken in January 2010 from approximately the same location. (Author's collection.)

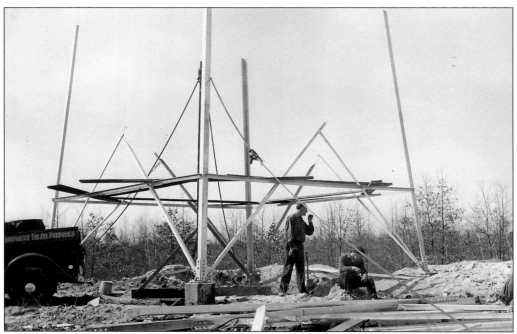

This photograph illustrates the construction of the fire tower being built on Tower Road in 1937. It appears they are on a break, as surely they knew they were being photographed. The man standing has his gloves in one hand, while drinking from his cup with the other. The second man seems to be resting, and still another is seated to the far right. His leg can be seen with his foot resting on the pile of fabricating steel. The Bender's, LaFazia's, and Daniel A. Clarke's properties were acquired in 1935 to accommodate this project.

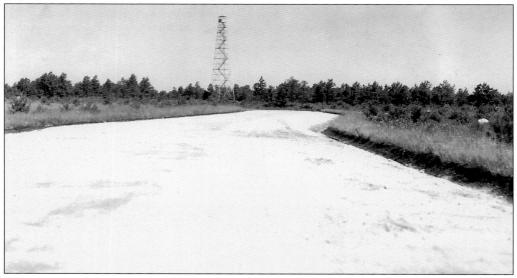

This photograph, taken on July 15, 1937, displays the newly constructed tower and Tower Road (Old Tunk Hill Road). It travels from the new Tunk Hill Road to the fire tower. The concern was if there were ever a fire in all these pines, there was a need for an early warning system and hence the building of the fire tower lookout.

Three

CREATING THE ASHLAND CAUSEWAY

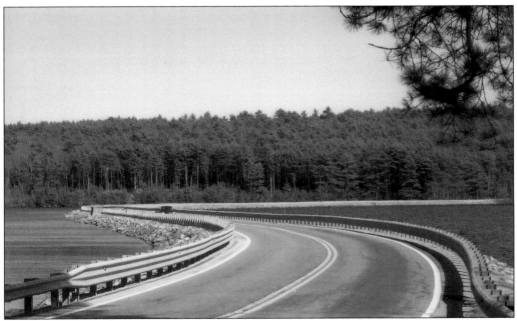

This photograph, taken in March 2010, shows the first section of the reconstruction of Plainfield Pike, the Ashland Causeway. This half-mile-long fill crosses the easterly arm of the reservoir and is 30 feet wide at its berm. It required 219,822-cubic yards of gravel fill. On top of the slopes, 9,354-cubic yards of broken stone and 28,798-cubic yards of boulders, or riprap, were placed over it to protect against wave action. A reinforced concrete culvert was constructed for the Moswansicut River to flow beneath it (see page 47). The project took a year and eight months to complete. (Author's collection.)

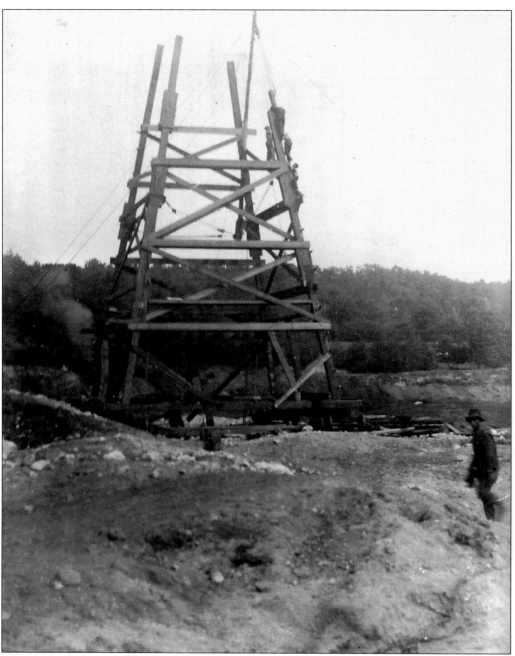

As he makes his way to the construction site, this worker notices his picture is being taken on Thursday, August 2, 1923. On the top right of the structure, three of his coworkers can be seen. They are constructing a 90-foot cableway dragline excavator tower. This one is being built on the south side of the causeway, looking easterly. It will be the mate of the one built on the north side. The village of Ashland is to the right of the photograph, as this configuration is being built in the residents' backyards. The following verse is from "The Farm" by Helen O. Larson: "That farm where we lived so many years ago / Will forever remain in my memory I know."

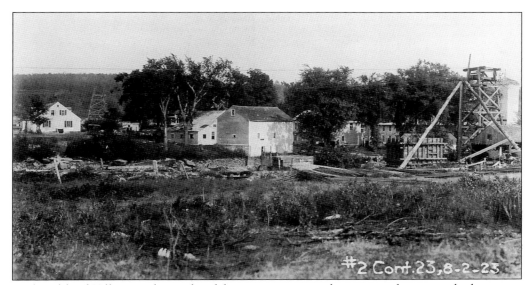

With Ashland Village in plain sight of the construction work going on, this view is looking east. To the right is the south cableway dragline excavation tower. The cable traversing to the north tower can be seen just above the tree line. The following verses are from "My Country Home" by Helen O. Larson: "When the evening Sun is setting, and I'm all alone / Memories take me back to, my old country home. During one of my lonely days, there wasn't much to do / So I got out the phone book, and found the address of you."

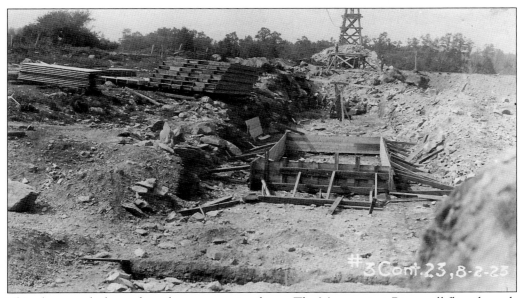

This photograph shows the culvert excavation forms. The Moswansicut River will flow through the 45-foot-tall culvert that is being built on this site. The north dragline tower is in the distance. All projects in the reservoir system are moving ahead on schedule.

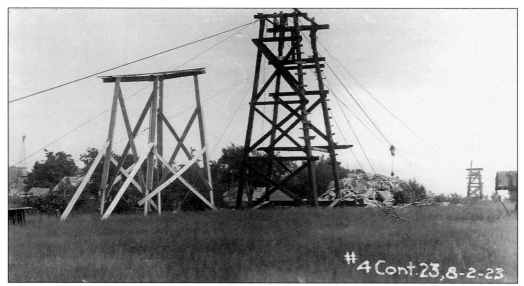

These cableway dragline towers were designed to cut a trench where the concrete culvert would be constructed. When finished, these towers would rise 60 feet above their base. In three years, when the reservoir would be filled to capacity, the remains of Ashland Village would be 37 feet underwater. The following verse is from "My Country Home" by Helen O. Larson: "I wrote you a letter and asked, if you remember when / You lived in one of the villages, that was destroyed way back then."

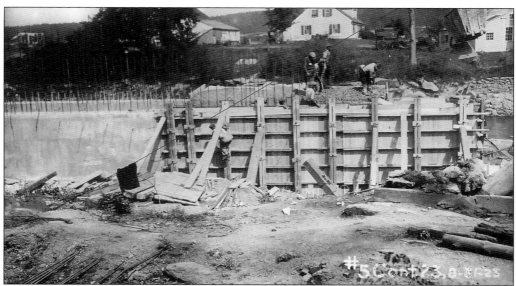

This photograph, taken on August 31, 1923, shows the forms and the pouring of concrete for the most southerly 35-foot section of the west-wing wall. There will be two of these walls on the south side and two at the entrance to the culvert on the north side, which is where the Moswansicut River will enter.

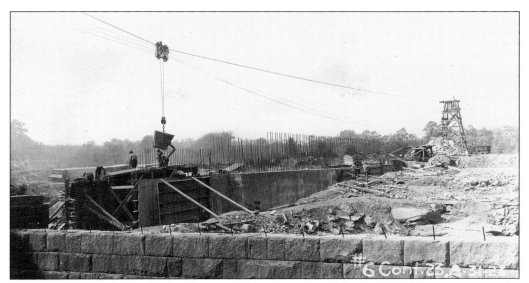

On August 31, 1923, the dragline has turned into a tool used for pouring the concrete into the forms for the wing walls. The worker has guided the bucket of concrete into position to be poured. It would then be returned to the concrete mixer to be refilled. The following verses are from "My Country Home" by Helen O. Larson: "And after several weeks, you appeared at my door / My letter in your hand, as you knocked on the door. I knew right away that, you could surely be / The boy that went, to school with me."

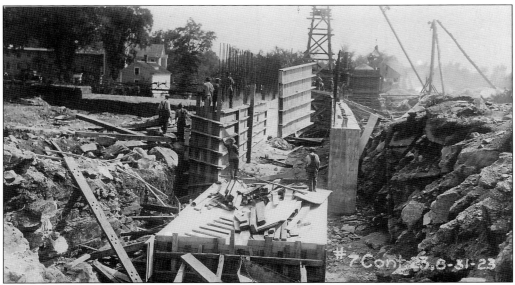

When the elevation of the walls reached a certain level, the forms would be built on top to raise the wall even higher. It can be noted that as the walls became higher, the dragline towers also needed to be built higher. This allowed them continue pouring into the forms from above.

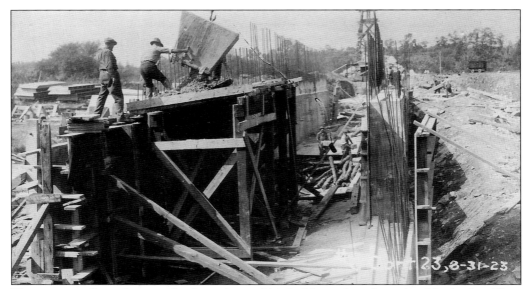

This is an excellent photograph of a worker and his buddy on the other side of the bucket. They are guiding it into position to pour its contents of concrete in the west-wing wall forms. Other workers are busy on the floor of the culvert. This is looking in a northerly direction. The following verses are from "My Country Home" by Helen O. Larson: "I asked you to come in, and sit down a while / And we talked of years gone by, when I was just a child. Sixty-nine years had past, since those old school house days / But that old school house, had stayed in our memories."

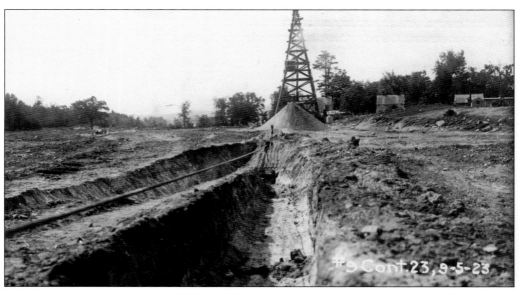

This photograph, taken on September 5, 1923, shows the cableway dragline excavator in operation. As shown, the gravel for the causeway was excavated from the immediate area. They are also creating a channel that the Moswansicut River will eventually be diverted to flow down through the culvert. Again, this is looking to the north.

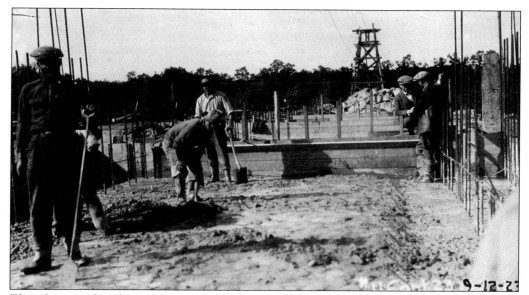

This photograph, taken on September 12, 1923, illustrates the progress being made. It is now called the Ashland Culvert, and these workers are busy pouring a 35-foot section of concrete in the lower floor of the culvert. Alphonso Tyler's property lay at the west end of the causeway, now partly under the causeway and most of the balance underwater.

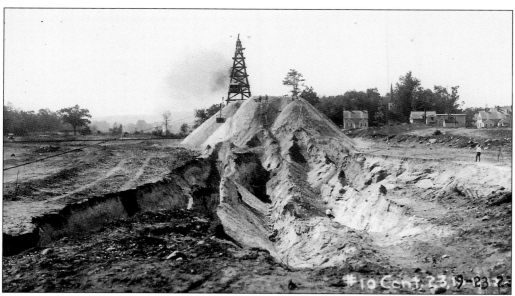

This photograph of September 23, 1923, is looking at the southern cable dragline in operation. The cable can be seen to the left, and the bucket is halfway up the pile. To give a sense of how huge this pile of gravel was, observe the two men standing on top of it. The Ashland Union Church steeple can be seen between the buildings and trees to the right.

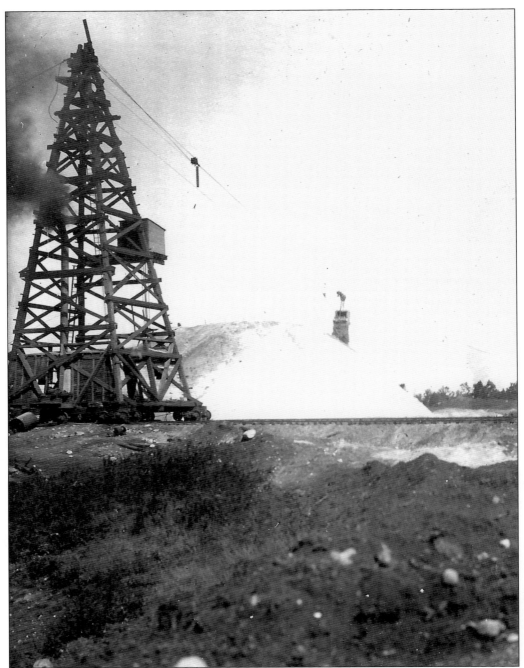

The dragline excavator tower has been maxed out in height, as this September 23, 1923, photograph illustrates. The towers were built on sets of wheels that ran on train tracks. Therefore, when they finished dragging gravel to the pile in one area, the towers could be moved to continue repeating this procedure for the entire length of the causeway. Construction on the causeway began on June 26, 1923, by the Thomas F. McGovern Company of Southbridge, Massachusetts, and was completed with a temporary roadway surface on February 10, 1925.

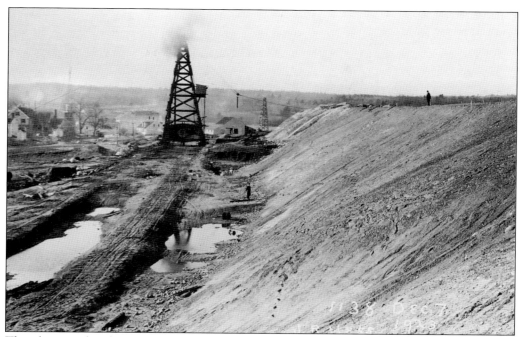

This photograph, taken on December 7, 1923, is looking westerly along the causeway's south slope. The village of Ashland is still hanging in there. However, the village would be drowned about two years later. The permanent bituminous macadam surface was completed on June 18, 1928.

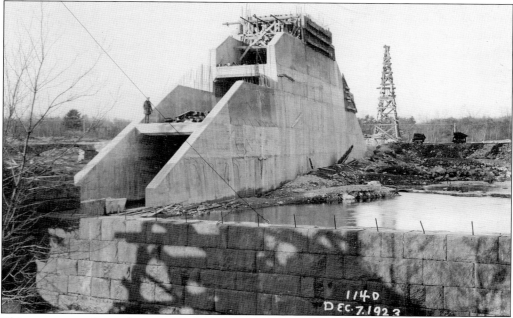

This concrete culvert, through which the Moswansicut River will flow, was built entirely upon rock. It has three openings. The bottom one is 16.5 feet, and the other two are 15 feet. The concrete slab on the riverbed is 215 feet long, the next one above is 180 feet long, and the top one is 110 feet long.

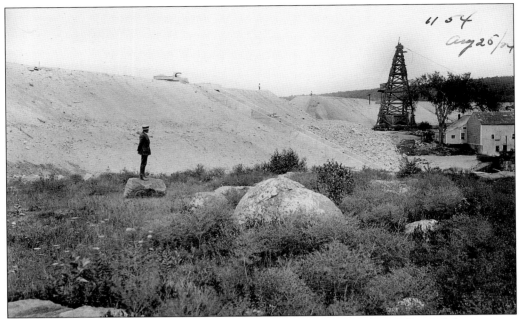

This August 25, 1924, photograph shows the causeway nearing completion. Beyond the concrete culvert can be seen a break in the fill. This is where the Moswansicut River was flowing while all this work was going on. When the river was diverted to flow through the culvert, then the balance of the causeway was filled in.

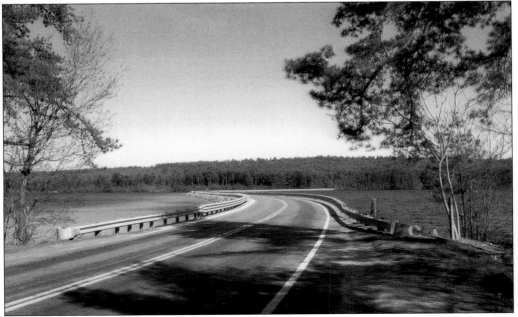

This photograph was taken the end of March 2010, which was after a record month rainfall of 15 inches. The reservoir was full and overflowing, flooding the Pawtuxet Valley (see page 66). The Ashland Village lies 37 feet beneath the water to the right of the causeway in the distance. (Author's collection.)

Four

CREATING HORSE SHOE DAM

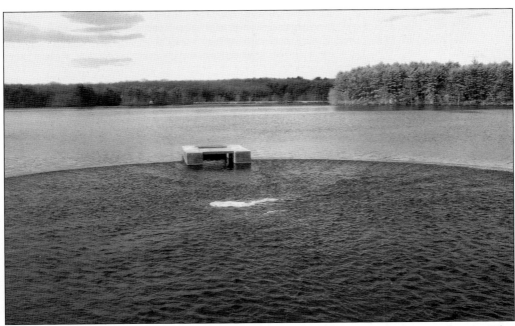

During the winter and spring of 1918, there was an unusual heavy consumption of water. This consequently depleted the distribution storage and required the immediate development of a reserve supply to carry the load until the Scituate Reservoir was completed. A swampy area between Danielson Pike and Hartford Pike, seen in the distance, was chosen, as it was scheduled to be flooded when the new reservoir was filled. Construction of the new dam began on September 2, 1918, and was completed on December 20, 1918. It reached full capacity for the first time in the spring of 1919. This photograph was taken April 13, 2010. (Author's collection.)

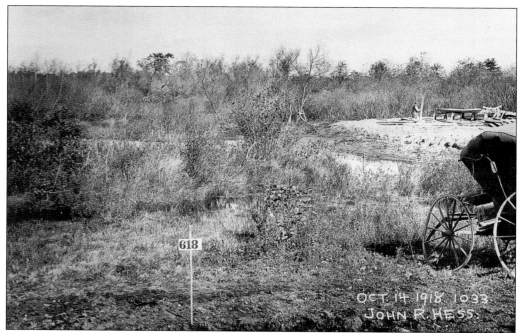

Lydia M. Bowen owned part of this land when John Hess took this photograph October 14, 1918. Beyond the tree line, looking in a northeasterly direction, lays Hartford Pike. This entire area was flooded once the Horse Shoe Dam was completed.

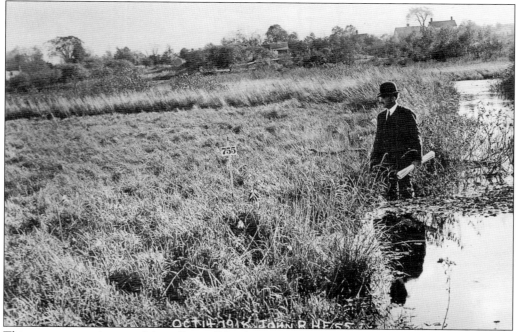

This swampy area is west of the village of North Scituate and on the North side of Danielson Pike. When it was flooded and filled to its flow line, it covered an area of 242 acres. Mabel F. Rice owned the land where this gentleman is standing. The houses in the distance are on Hartford Pike.

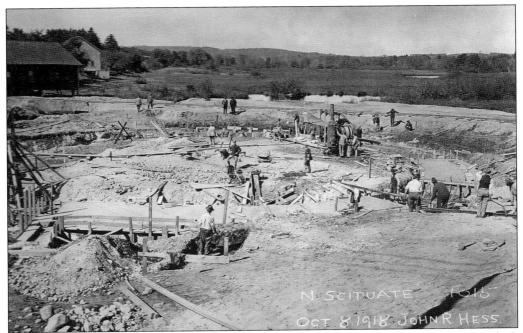

Construction of Horse Shoe Dam began one month before this October 8, 1918, photograph. It appears work is progressing very quickly. Benjamin F. Smith, William F. Angell, and William H. Smith all owned lots that were taken for this project.

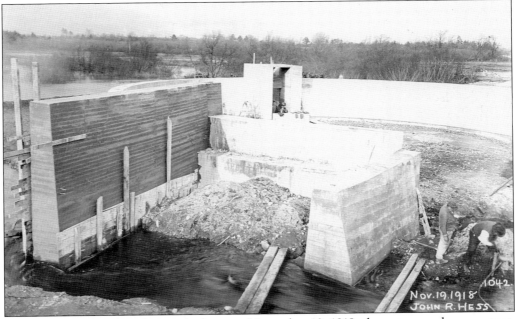

This photograph, taken five weeks later on November 19, 1918, shows tremendous progress. The swamp area can be seen beyond the dam that will be flooded. This area was later named Regulating Reservoir, as water can be released when needed. At this time, the Moswansicut River is flowing around it.

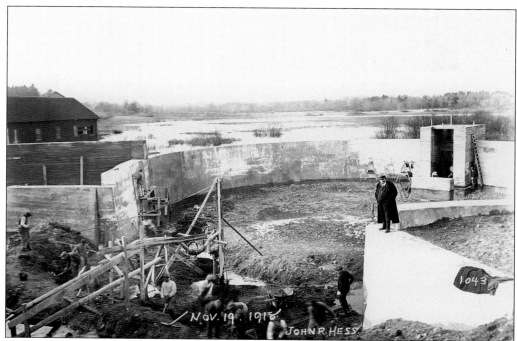

The E. W. Foley Contracting Corporation of New York City constructed the dam and a portion of Danielson Pike that needed to be regraded. The circular dam has a diameter of 100 feet, with an effective length of 219.5 feet. It has wing walls that connect the dam to the Danielson Pike Bridge. The surface outside the circular wall of masonry on the reservoir side was covered with an impervious soil blanket for a distance of about 75 feet. Below, the photograph, taken in February 2010, displays the 428 million gallons of water the dam holds in reserve. (Author's collection.)

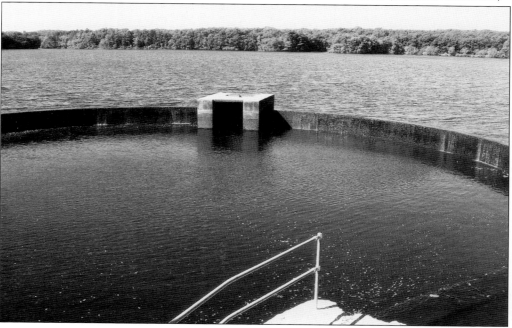

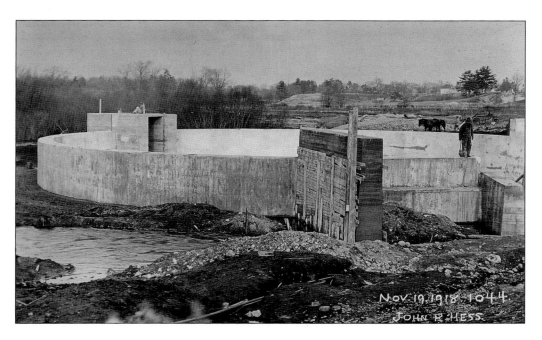

John R. Hess took this photograph on November 19, 1919, from the north side of Danielson Pike, looking in a northeasterly direction. Hartford Pike would be in the distance. Between November 10 and 18, 1923, 137 million gallons of water were drawn from the Moswansicut Pond to fill the Regulating Reservoir. Moswansicut Pond contains 1,781 million gallons when full; however, only 715 million gallons are available. The photograph below, taken from approximately the same location as the photograph above, shows the reserve after three days of steady rain in March 2010. (Author's collection.)

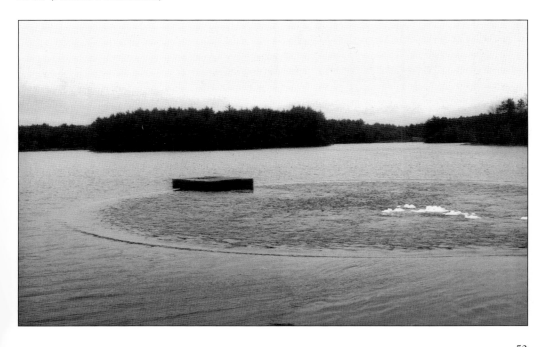

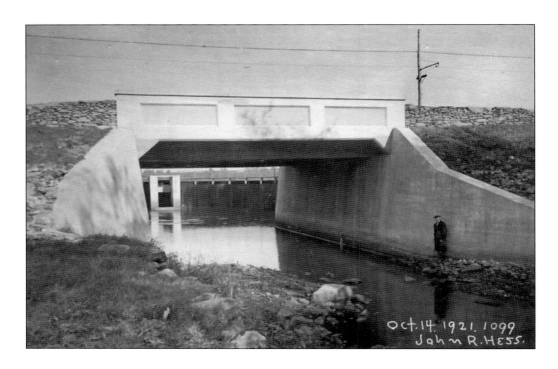

On October 14, 1921, the water level of the reservoir was quite low. Horse Shoe Dam can be seen under Danielson Pike Bridge. When the Scituate Reservoir is full, the water stands about 4 feet below the bridge, which means the man standing beside the bridge abutment would be underwater. The photograph below, taken in January 2010, shows the water level about 4 feet from full. It seems the small stonewalls have been replaced with much larger stones. (Author's collection.)

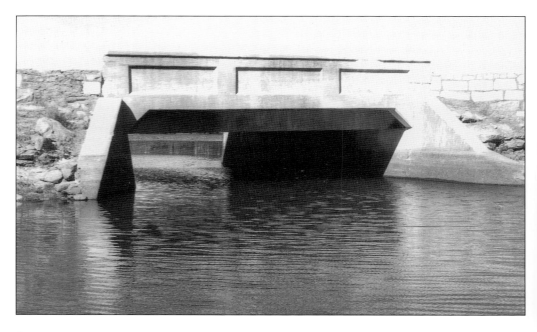

Five

CREATING THE SPILLWAY AND BRIDGE

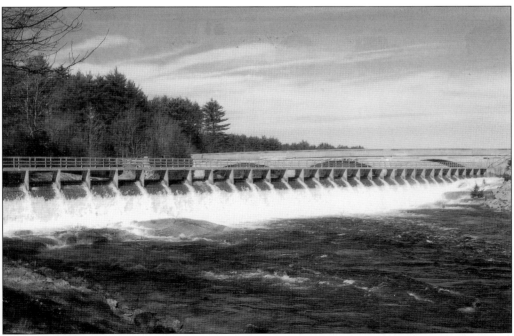

This photograph was taken on March 16, 2010, after three consecutive days of rain. The three-span reinforced concrete bridge carries vehicular traffic over the basin area, which was designed for excess water to flow over this spillway weir. This prevents the water from rising to the top of the Gainer Dam. The Winston and Company of Kingston, New York, was awarded the contract on May 4, 1921, to build the spillway weir and the spillway bridge. (Author's collection.)

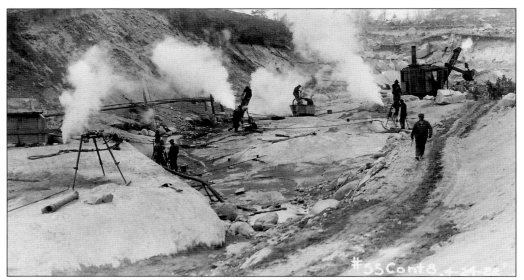

This photograph, taken April 24, 1922, is looking west, showing exposed ledge and grout holes being drilled by the workers. In the distance, an Erie shovel can be seen clearing off the ledge. There is a wagon with a team of mules in front of it, waiting patiently to be loaded.

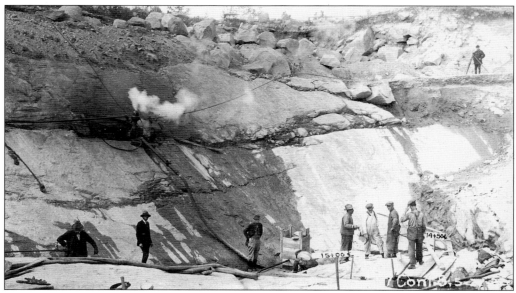

This photograph, taken on May 27, 1922, is also looking west, showing the exposed face of ledge. Asa E. Colvin owned this 5-acre property, until it was taken to build the spillway structure.

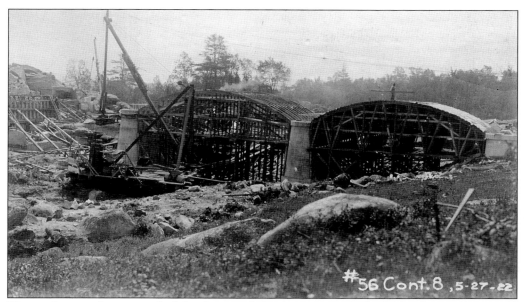

The roadway at the west end of the dam needed to continue over the body of water that would lead to the spillway. Therefore, a three-span bridge needed to be built. It is called the spillway bridge. This photograph looking south was taken on May 27, 1922.

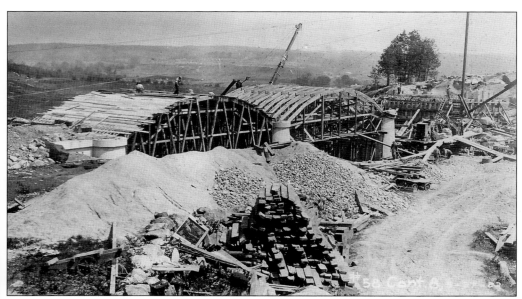

This is looking northeasterly, showing the false work for the center and westerly piers. The Gainer Dam is to the right, Tunk Hill Road is to the left, and behind it will be completely flooded. The workers of Winston and Company are moving ahead at a very fast pace.

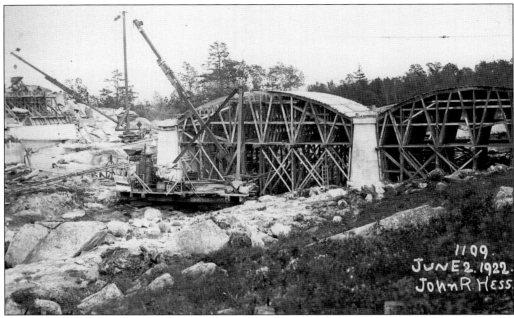

This photograph shows a depression at the westerly end of the Gainer Dam that would provide a natural spillway basin for the reservoir. Therefore, a three-span reinforced concrete bridge was needed to carry vehicular traffic over the basin. This view is looking easterly from the west end of the dam.

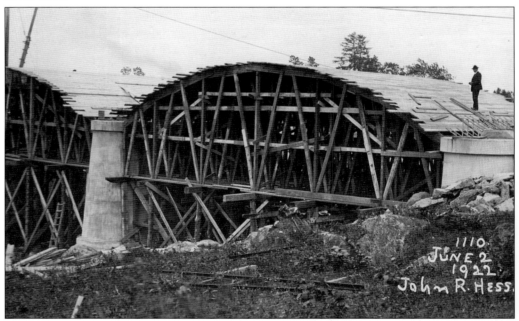

This photograph, taken on June 2, 1922, gives a close up view of the enormous timbering in place for support of the west arch. Once the concrete bridge was in place, all this timber would be removed. This photograph was taken from the north side of the bridge at the west end of the Gainer Dam.

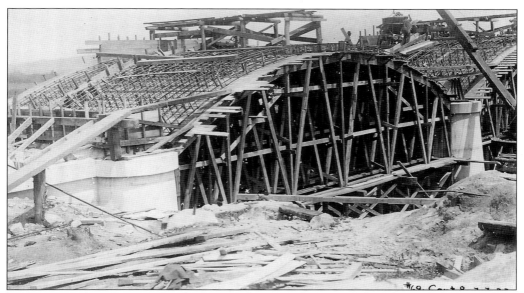

It appears in this photograph, which was taken on July 7, 1922, that the workers are making great progress. This is showing that the false work, plus all the reinforced steel, is in place for the westerly arch and workers are getting ready to pour the concrete.

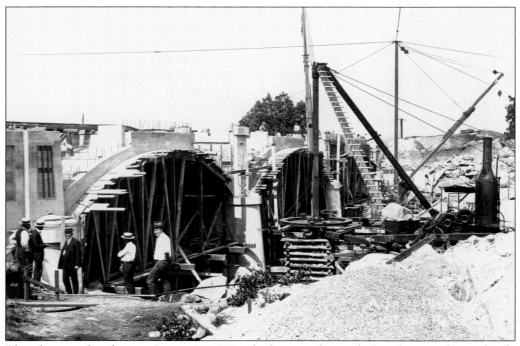

This photograph, taken on August 14, 1922, is looking northeasterly. It is showing the south side of the bridge after completion of the arches and cross walls over the piers. In the lower left corner is possibly a group of officials checking the progress of the project.

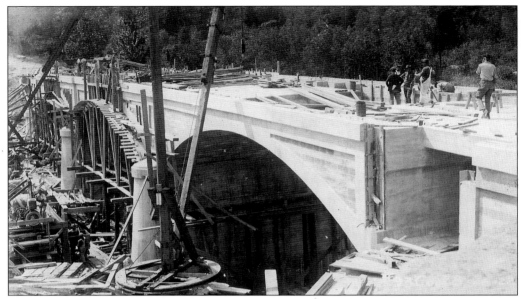

This photograph illustrates on September 8, 1922, the false work that is still in place on the center and west spans. The false work has been removed from the east span. This photograph also gives an excellent perspective of what the bridge will look like when completed.

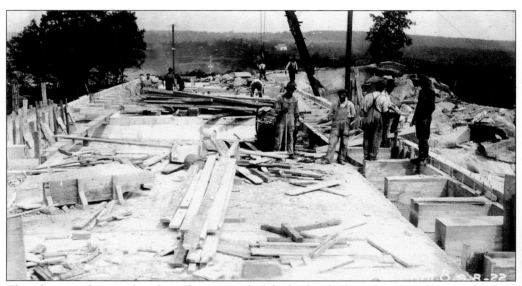

This photograph was taken from the west end of the bridge, looking east. It is showing the floor slab in place, as the workers continue to complete their project. The sidewalk cross walls are also in place on both sides of the bridge. The reservoir will be to the left.

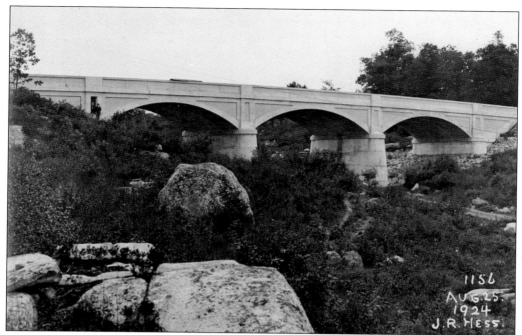

This photograph, taken on August 25, 1924, gives a good view of the spillway bridge completed. It is looking in a northerly direction from below the west side of the bridge. Water will flow under these arches on its way to and over the spillway weir, during its quest to join the Pawtuxet River.

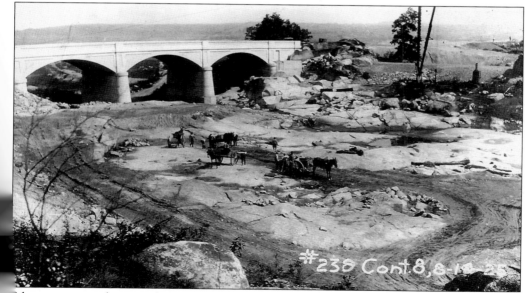

Almost one year later on August 14, 1925, work has begun on the spillway basin. The rock is being cleaned off in preparation of constructing the spillway. This was taken from near the west end of the weir. In 1925, they are still using teams of mules in this enormous project.

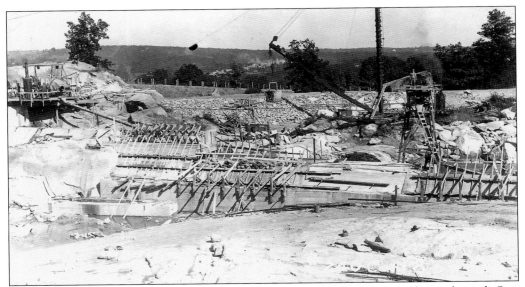

This view from September 23, 1925, shows the upstream face of the weir being formed. One section is ready for the concrete to be poured. In the background, the poles can be seen that will receive the guardrails for the access road. The access road would travel below the dam toward the purification plant.

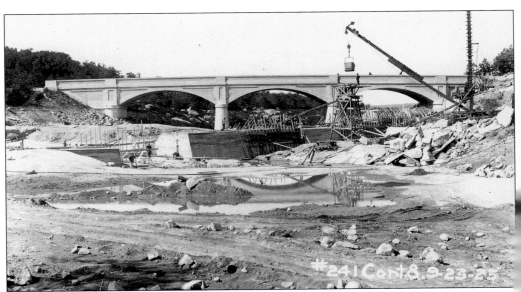

This photograph was taken the same day as the one above. However, it is of the downstream face of the weir. It also shows the concrete bucket ready to pour into one of the formed sections. This also gives a great view of the completed spillway bridge, looking to the north.

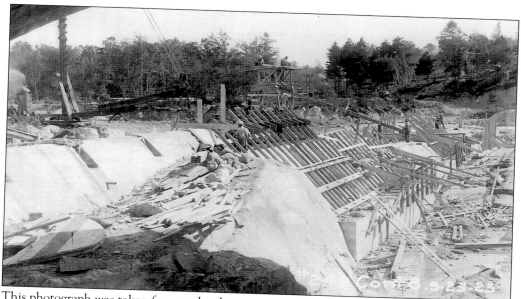

This photograph was taken from under the east span of the bridge. It shows two sections of the weir are complete and the forms have been removed. The next section is formed and being poured with concrete. The grooves in the top of the weir are for flashboard standards.

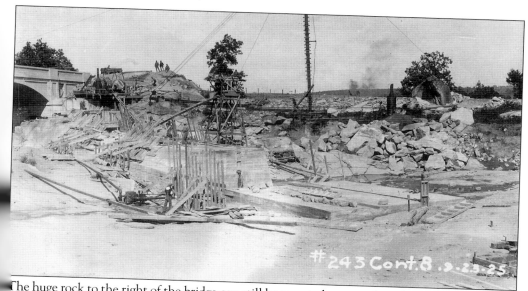

#243 Cont.8 .9.23.25

The huge rock to the right of the bridge can still be seen today, even though no longer accessible o the public. It shows vertical contraction grooves and a 5-inch horizontal plate for water stop. n less than two months, the reservoir will start to be flooded, but this height won't be reached or a year.

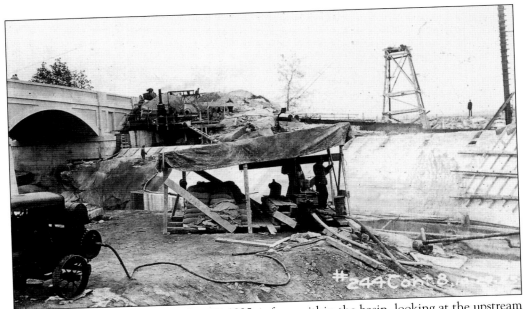

This photograph, taken on October 27, 1925, is from within the basin, looking at the upstream face of the weir. To the left, the grouting machine is being used to grout the foundation under the weir. They have rigged up this shelter to protect the grouting material from the elements.

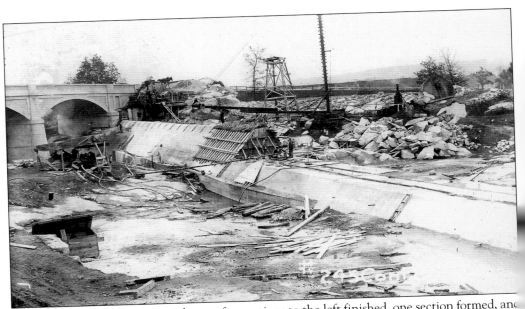

This upstream view of the weir shows a few sections to the left finished, one section formed, and the foundation completed. Work is progressing right on schedule. The flash boards mentioned earlier could be installed at any time to raise the height of the storage of water in the reservoir

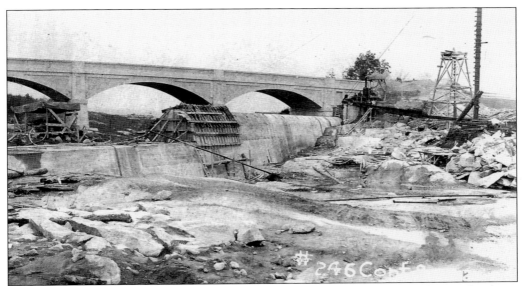

This photograph is taken from below the weir looking north at the downstream face. It also shows the ledge below the weir, which is where the water will eventually flow over. This photograph was also taken on October 27, 1925.

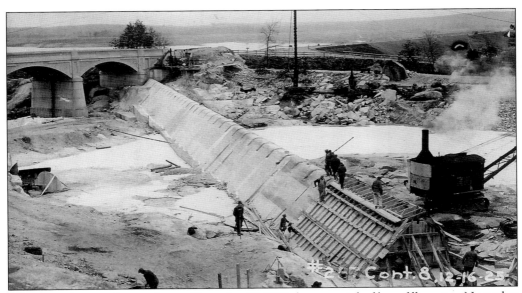

When this photograph was taken on December 16, 1925, the reservoir had been filling since November 10, 1925. The reservoir is taking shape, as can be seen over the bridge in the distance. Even though it is a cold Wednesday in December, work must continue as they are racing against time.

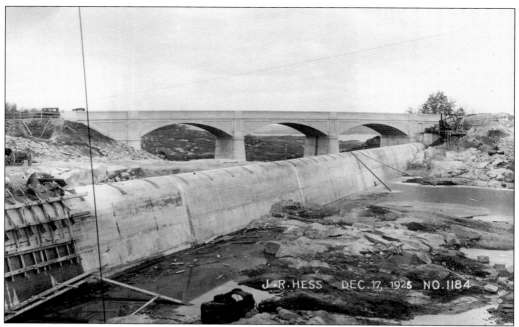

The completed weir is 413 feet long and was built in 44 bays. The discharge over the spillway flows through a 1,800-foot spillway channel to the Pawtuxet River. It falls 88 feet in that short distance. Looking through the bridge arches, the reservoir can be seen filling in the distance.

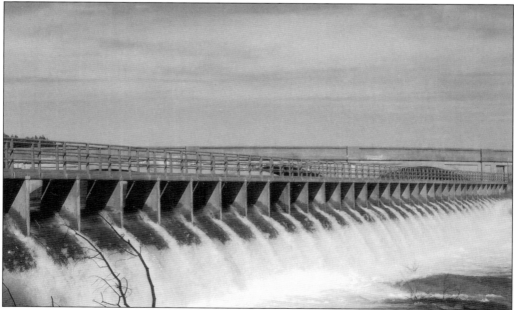

This photograph, taken in March 2010, is after three days of heavy rains. The reservoir is full, and the excess is flowing over the spillway, as it was designed to do. Downstream on the Pawtuxet River, in the West Warwick area, there was major flooding. The river rose 10 feet above flood stage. Heavy rains the following week caused the worst flooding in over 100 years, raising the river to 19 feet above flood stage. (Author's collection.)

Six

CREATING THE GAINER DAM AND DIKE

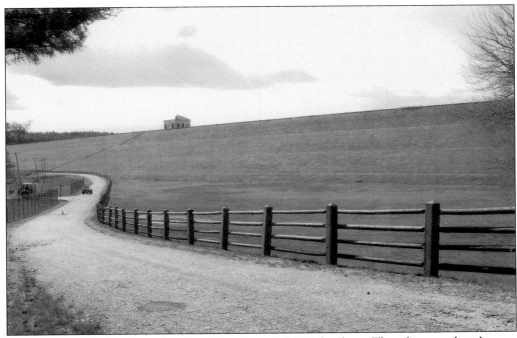

The Gainer Dam, known to locals as Kent Dam, is 3,200 feet long. This photograph, taken on April 13, 2010, does not show the entire length of the structure. The access road travels along the bottom of the dam and ends at the top at the west end of the dam. The line going from the road to the gatehouse at the top is 160 stairs long. They are no longer accessible. (Author's collection.)

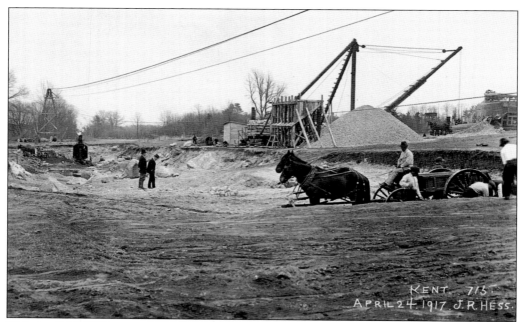

This April 24, 1917, view at the conduit location is looking south. The conduit to be built will be 462 feet long and will carry water under the dam to the Pawtuxet River. When completed, it stands 21 feet, 4 inches high and 25 feet wide. The men at the right are stripping the top soil by hand.

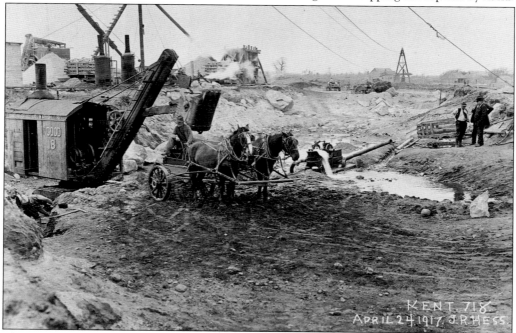

This photograph is taken from the opposite end of the control conduit trench, looking north. In the foreground is an 18-ton Osgood Shovel loading a dump wagon drawn by a team of horses. It also shows the characteristics of boulders in the area. Work will soon slow down for lack of manpower, as the United States has declared war with Germany on April 6, 1917.

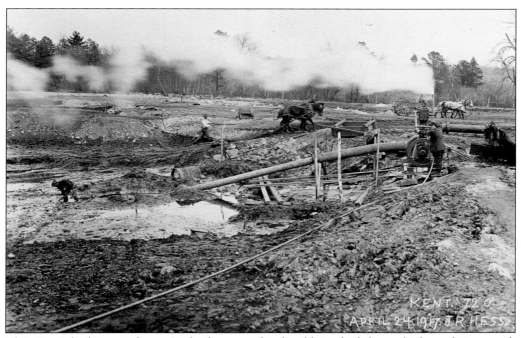

This view is looking southeast. In the foreground is the old riverbed, from which muck is scraped. A centrifugal pump, shown on the right, has removed fluid muck. A spoil bank for waste material is in the background. The river will be diverted to flow through the conduit.

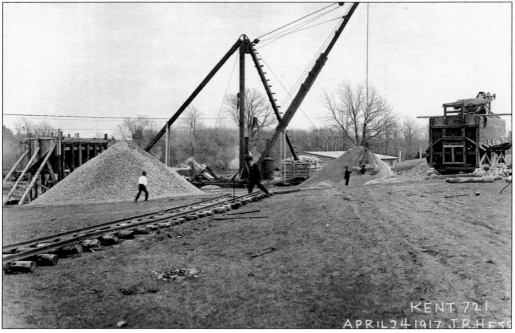

This photograph displays the concrete plant including the crusher, screens, cement house, stiff-leg derrick, and storage bins of sand and stone piles. During the war period, the work force was reduced from 73 to 26 men. John Hess took both of these photographs on April 24, 1917.

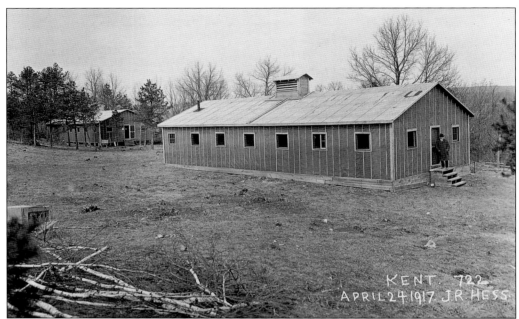

Both of these photographs were taken on April 24, 1917. The magnitude of the project required the establishment of a construction camp. The photograph above is looking northeast at the camp, showing two 24-man bunkhouses. The camp contained 106 buildings. Besides the 24-man bunkhouses, it also included an office, commissary (below right), cookhouse (below center), cottages, saw sheds, garage, barns, storehouses, oil sheds, miscellaneous buildings, and a hospital. The hospital maintained a resident physician and a trained nurse in attendance. The maximum number of residents at the camp totaled 458. This included 371 men, 44 women, and 43 children. The 18-acre camp was located on city property, about a half mile south of the dam. It was situated on the east side of Kent to Hope East Road.

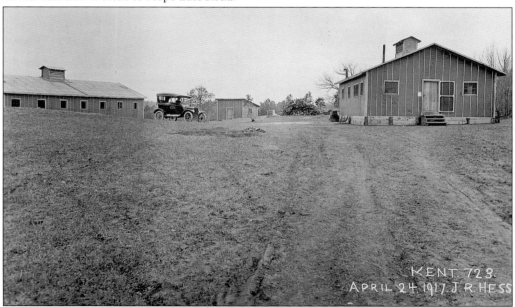

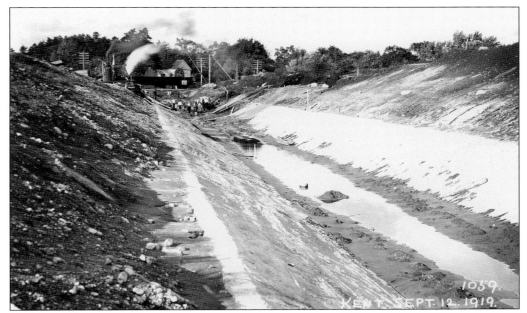

On May 16, 1919, work was resumed on the Gainer Dam Project. This view on September 12, 1919, shows the river diversion approach channel, looking northeasterly. The Pawtuxet River will be diverted to flow down it to the conduit beneath the dam. The Kent Baptist Church and the Red Bridge, carrying the Kent to Coventry Road, can be seen in the distance. The photograph below shows the river diversion approach channel from the northerly end of the curve, looking south into the river diversion conduit. As soon as this part of the channel is concreted, the river will be diverted.

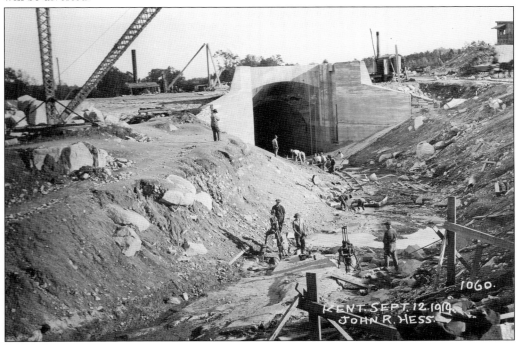

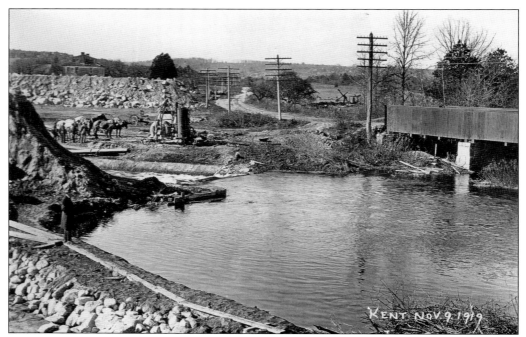

This photograph was taken November 9, 1919. In the lower left corner can be seen the diversion dike built at the upper end of the approach channel. The abandoned Red Bridge is to the right, and beyond the bridge, in the distance, is an Erie Shovel stripping soil for the core of the dam.

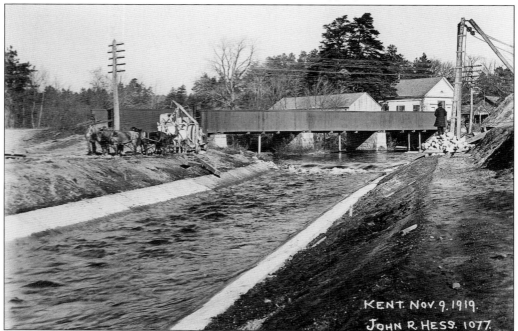

This is an excellent view of the abandoned Red Bridge and the buildings of the Kent Baptist Church. The Pawtuxet River was diverted into the upper end of the approach channel on November 5, 1919, and would never flow its original course again. The river diversion was complete.

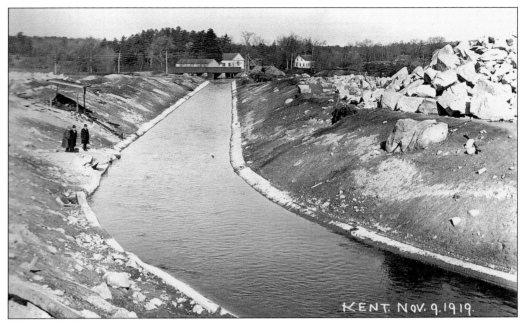

From a point just before the location the river would enter the stream control conduit, this photograph is looking upstream along the approach channel. The Pawtuxet does not know it, but in a handful of years, it will no longer be a river in this area, as it will be 90 feet under the Scituate Reservoir.

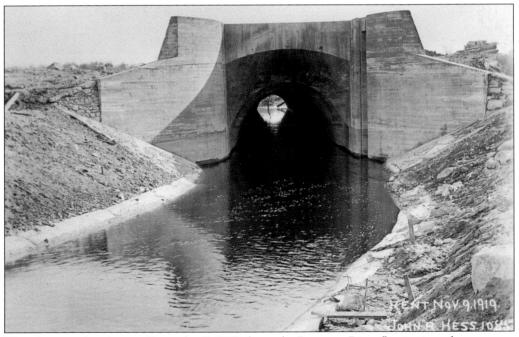

This photograph, taken on November 9, 1919, shows the Pawtuxet River flowing into the upstream end of the 462-foot long stream control conduit. Now that this had been accomplished, the remainder of the dam construction could move forward.

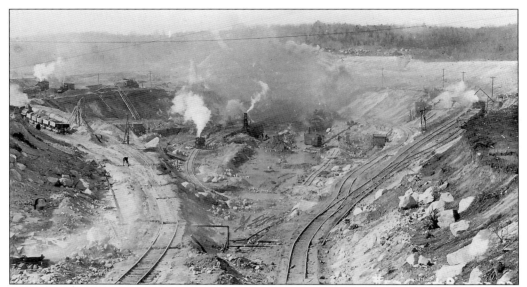

This photograph was taken on March 23, 1922, showing the excavation of the core trench. The material was removed from the trench by narrow gauge 4-cubic-yard dump cars. Twenty-ton Dinkey Locomotives, operating on each side of the trench, also hauled the material.

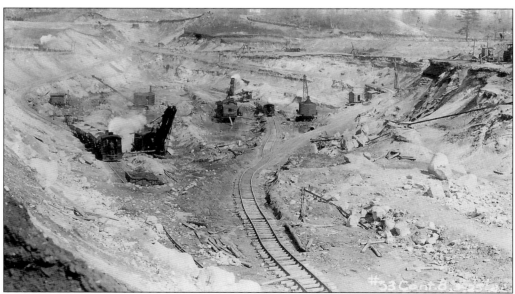

Progress is evident in this photograph from March 23, 1922, showing the removal of soil of the core trench that began on July 25, 1921. Employed in the excavation work were railway traction shovels with 2.5-cubic-yard buckets, smaller steam shovels with buckets ranging in size from .75 to 1.25 yards, and a dragline excavator, which operated where it was difficult for a shovel to maneuver.

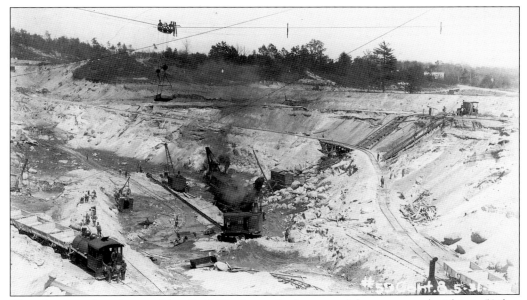

This photograph, taken on May 31, 1922, shows the bottom of the core trench. This is 50 feet left of the centerline of the dam, looking east. A number of Erie Shovels can be seen clearing off the ledge.

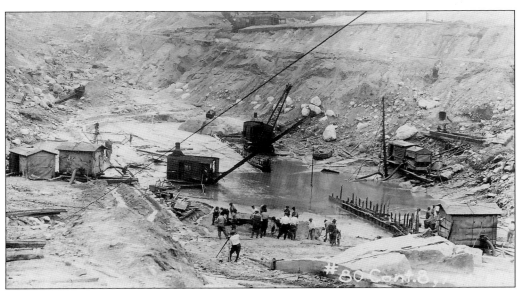

This photograph from July 24, 1922, shows the deepest portion of the core trench, looking east. The photograph was taken after heavy rains had washed considerable amounts of sand and debris onto the rock and had filled the sump on the north side, above the top of the wall. The core trench was dug 100 feet below the elevation of the riverbed to solid rock.

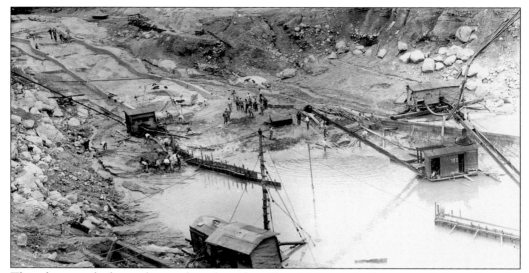

This photograph shows the north and south walls, which were built on top of the rock at the bottom of the core trench. This was also taken on July 24, 1922, and clearly depicts the damage the heavy rains had done. Both walls have been covered with sand and debris, including the area flooded.

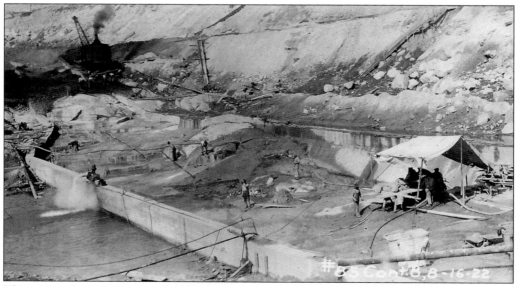

This view, taken on August 16, 1922, shows the water pumping out and the sand being removed from the 8-foot-tall retaining walls. It appears they have set up shelter from the hot sun of August. Work will continue year round to complete the project.

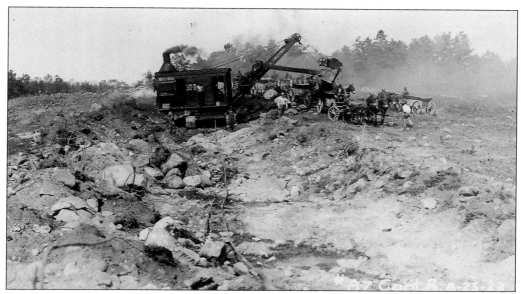

On August 23, 1922, this No. 30-B Steam Shovel is stripping soil from a field that is east of the North Scituate to Kent Road. It is loading a 2-cubic-yard bottom dump wagon drawn by a team of mules. There is another team waiting in line, as even another team circles to approach the shovel. On the west side of the road, abutting the Pawtuxet River, Adoniram J. Hopkins owned 28 acres here.

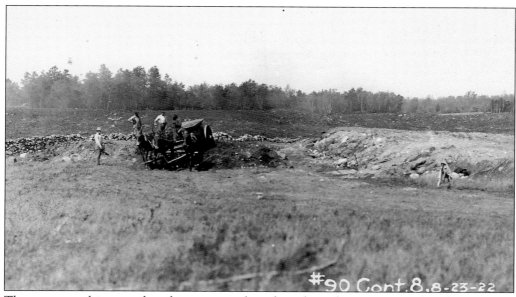

The team was driven to the adjoining parcel to place the soil in a storage pile. The team was backed up to the pile, and then the floor of the wagon was released to unload its contents. The trees in the distance are part of Edward F. Page's 134-acre farm. His frontage was on the Old Plainfield Pike. It was in the water shed area and therefore taken.

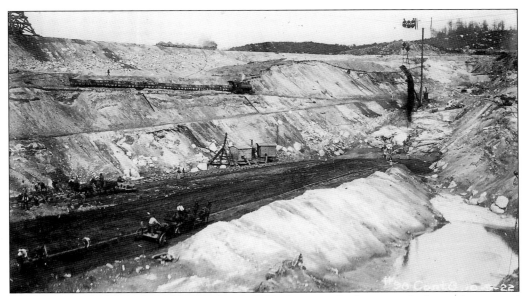

The photograph above, taken on October 9, 1922, shows in the foreground a horse-drawn road machine spreading soil. In the upper right area is the cableway dumping a bucket of soil. The magnitude of this project required the installation of a standard gauge 2.3-mile railroad spur over a right-of-way from the village of Jackson. This railroad went through Mr. Keenan's cow pasture, which is now owned by the author, and ended at the site of the dam. Construction of the spur began on May 28, 1921, and was completed and ready for use on August 13, 1921. The contractor leased a 54-ton, 6-wheel steam locomotive with 5 flat cars. This allowed all equipment, coal, cement, and other supplies to be delivered to the site without having to be rehandled. The following verse is from "The Old Railroad" by Helen O. Larson: "My son Ray and Ramona's house stands where a railroad ran one day / And the little engine sounded loud as it blew its whistle each day." The author found the railroad spike pictured below when his driveway, which follows the old railroad bed, was being excavated. (Author's collection.)

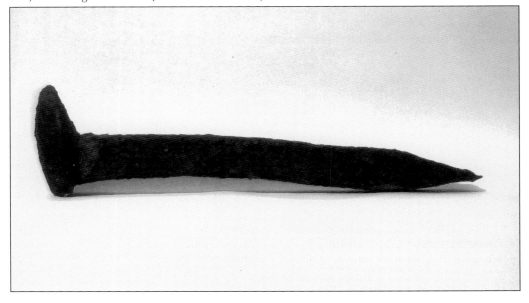

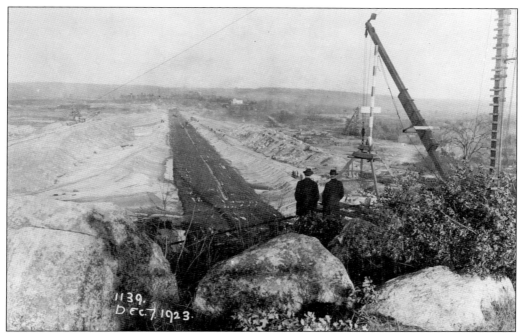

This photograph was taken from the west end of the dam construction on December 7, 1923. The two men in the foreground are standing at approximately the location of the beginning of Tunk Hill Road today.

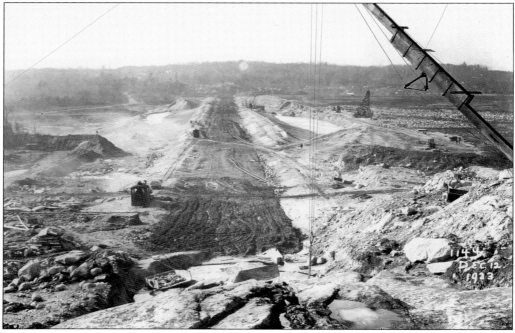

This photograph, taken December 12, 1923, is a view from the east end of the dam, looking westerly toward Tunk Hill Road. The downstream face of the dam is to the left. The diverted river can be seen to the center right.

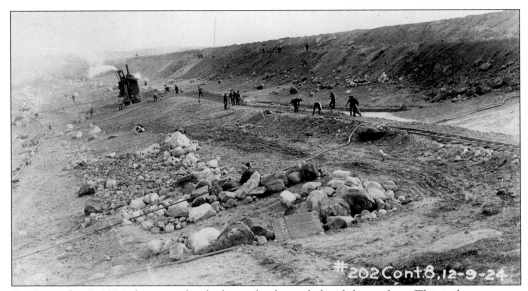

On December 9, 1924, there is only a little patch of snow behind the workers. This is the upstream face of the dam. It shows the slope being trimmed by a 14-B Shovel and the first riprap placed on the slope below the railroad tracks. The following verses are from "The Old Railroad" written by Helen O. Larson on August 31, 1999, at the age of 88: "It used to carry coal, and other supplies too / Up to where, the dam stands anew. They used the coal, for the steam shovel then / If I can listen now, it seems I hear that whistle again."

On January 9, 1925, there still is only a little snow. This is the year the reservoir will begin being filled. This is the west end of the dam, showing riprap at elevation 250. The train tracks are on the 267 berm, and the top of the dam is at elevation 390. Work continues through the winter.

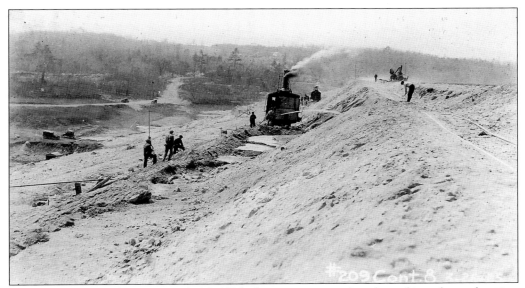

This photograph, taken on March 26, 1925, shows two steam shovels working above elevation 266. Also the access road, which passes the spillway and travels below the dam, can be seen in the upper left area. The dam will be 3,200 feet long when completed.

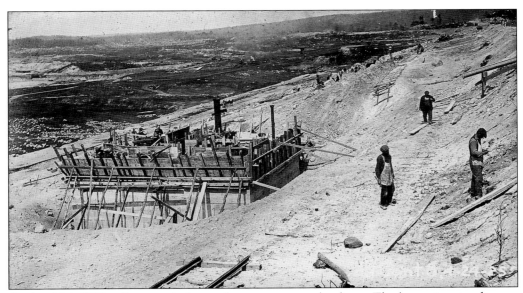

As April 24, 1925, rolls around, the gatehouse starts to take shape. The large pipe standing up above the rest of the structure is the 16-inch, cast-iron pipe, which will form the float well. This view is looking east toward, which is where the water will be.

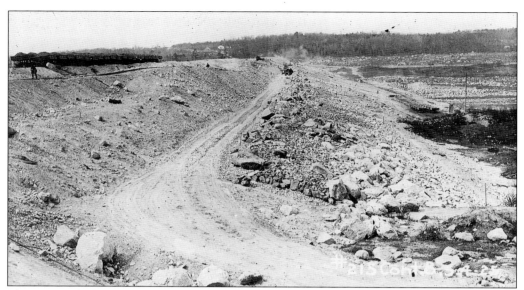

This is a view looking at the riprap from the east end of the dam below the 267 berm. This photograph shows the slope of the riprap and the slope of the dam below the berm on May 4, 1925.

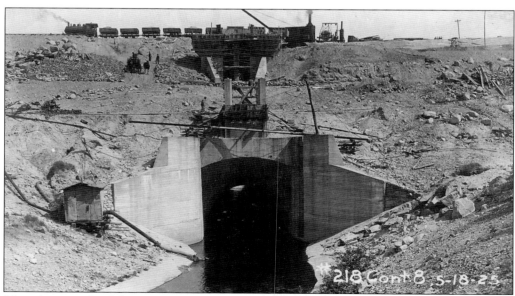

This photograph of the upstream slope of the dam was taken on May 15, 1925. It shows the entrance to the conduit and intermediate intake partly built. The following verses are from "The Old Railroad" written by Helen O. Larson: "Finally the dam was finished, and they tore up the track I know / And I think there were many people, that didn't want it to go. So no more does the little engine, run on the track each day / For they pulled up the tracks, and hauled them away."

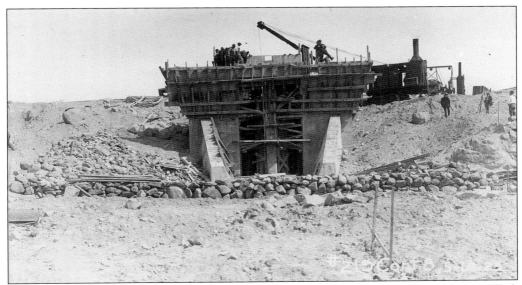

This view of the upstream face of the dam is showing the upper intake to the gatehouse. Work is progressing on schedule on Monday, May 18, 1925.

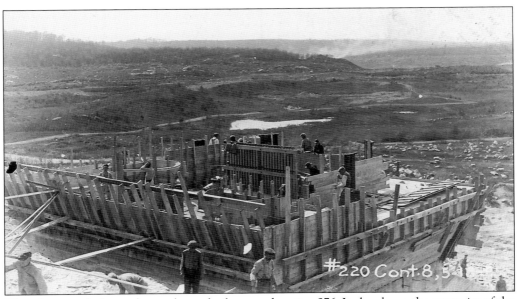

This photograph shows the gatehouse built up to elevation 276. It also shows the enormity of the size when compared to the men in the lower right corner. In the distance can be seen the area that will start to be flooded in less than six months on November 10, 1925.

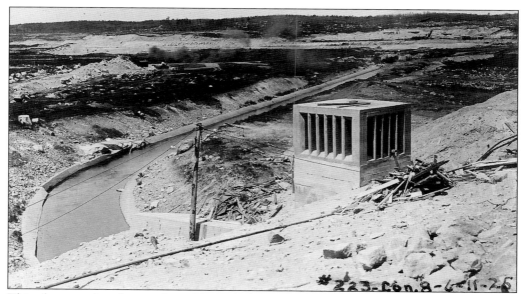

This photograph, taken on June 11, 1925, shows the intermediate intake is completed. The Pawtuxet River is flowing down the approach channel and under the dam. In just five months, the water would start rising to cover the entire area. This was taken from the top of the dam, looking north.

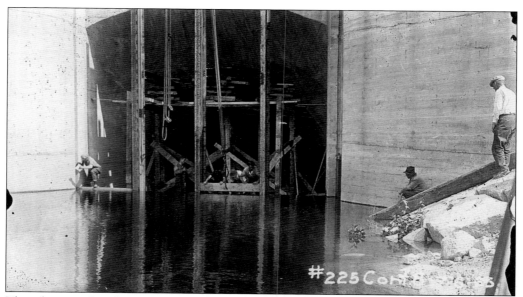

This photograph, taken on June 25, 1925, shows the approach channel entering the conduit. Several workers are placing stop logs between the 24-foot I-beams to begin raising the water to go through a 36-foot pipe located under the dam. After being drowned by the rising waters of the reservoir and losing its identity, this conduit will give the Pawtuxet River new life, as it flows out of the other side of the Gainer Dam and down through the Pawtuxet Valley.

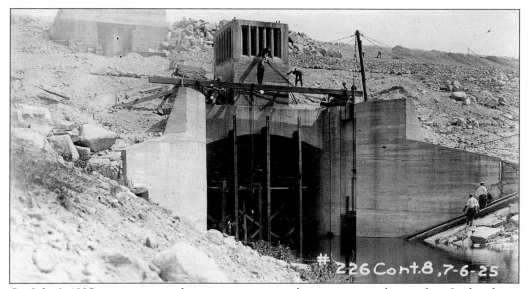

On July 6, 1925, it is apparent the water is rising at the entrance to the conduit. It also shows the 3-by-5-foot gate and the intermediate intake. The gatehouse at the top of the dam is being constructed, which includes the installation of sluice gates, the water wheel, and the hydroelectric turbo generator.

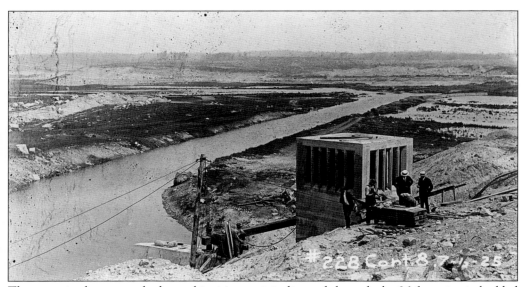

The water in the approach channel is rising, as it is diverted through the 36-foot pipe imbedded in the conduit wall. The conduit is blocked off to allow work to continue in the interior. It must have been hard to believe that soon this entire valley would be flooded.

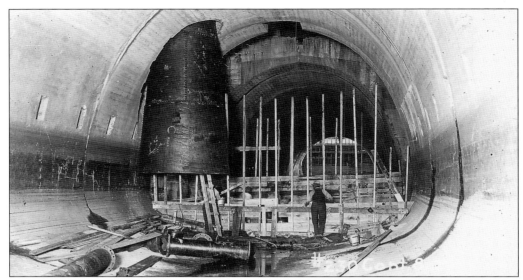

This photograph, taken on August 8, 1925, shows extensive work being done inside the conduit. The draft tube is complete at the bottom of the Mill Supply Well. It shows forms are being set for the bottom plug at the gatehouse and forms for the curtain wall at the entrance to the conduit.

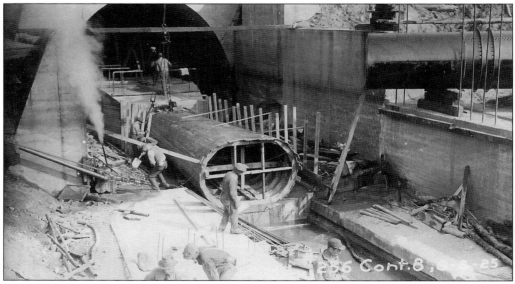

This shows the form being set for the elliptical venture meter. Also, blocked up on the east wall of the chamber is one of two 60-inch steel pipes that will carry water to the purification plant. The following verses are from "The Scituate Reservoir" by Helen O. Larson: "People in Providence, needed clean water to drink / The city bought five villages, people had to sign with pen and ink."

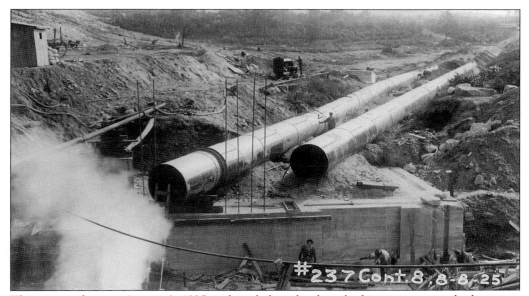

This view, taken on August 8, 1925, is from below the dam, looking in an easterly direction. It shows the two 60-inch pipelines, which extend from the meter chamber on their way to the purification plant.

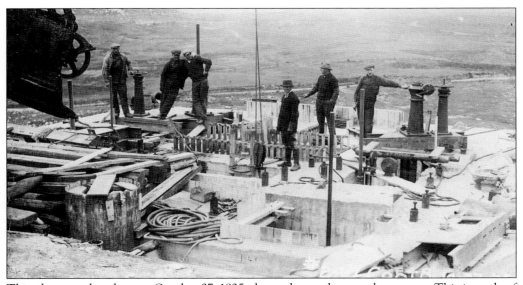

This photograph, taken on October 27, 1925, shows the gatehouse substructure. This is made of concrete with granite facing on the exposed portions. The outside of the building was constructed of bricks with granite trims. Originally, the roof was Spanish tile. The lower of three floors is 12 feet below road grade.

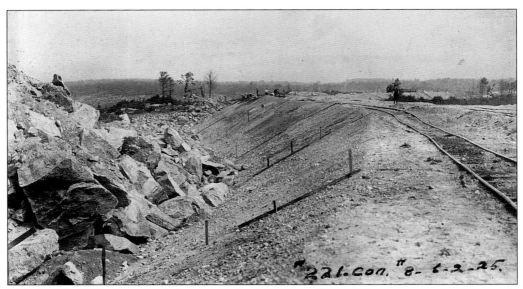

This June 2, 1925, photograph shows that the 3,900-foot dike and the dam were simultaneously under construction. The dike would reach from the east end of the dam, along the side of the relocated Bald Hill Road, to the new East Road. Its construction was similar to the dam, an earth structure with an impervious soil core.

Taken in January 2010, this photograph shows the completed dike at the same curve. In 1963, the road extending from the east end of the dam to the new East Road (Route 116) was reconstructed and straightened; therefore, Bald Hill Road was abandoned. For security purposes, it has been blocked off since the attack on the Twin Towers on September 11, 2001. (Author's collection.)

This view of the extreme east end of the dike, taken from the new East Road, shows 5-ton motor trucks hauling soil on May 10, 1925. Even though there are dump trucks in this photograph, there are still teams of horses at work. The Sarah A. Rogers Estate owned these 30.76 acres, with 587 feet of frontage on Bald Hill Road. It also included two cemeteries.

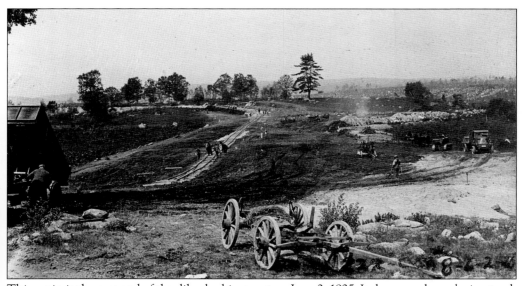

This again is the east end of the dike, looking west on June 2, 1925. It shows workers placing track on the core for bringing in gravel. In the lower left corner of the photograph, a driver is dumping his load of gravel. The center right area will be totally underwater.

This view on July 16, 1925, is looking west from the east end of the dike. It is showing the structure trimmed and ready for the soil dressing. The work is on schedule, and the reservoir will start to be filled in four months.

This photograph, taken from the same location in August 2009, shows the completed grass covered dike. As mentioned previously, the area behind the row of trees on the right is totally covered by water. (Author's collection.)

Seven

CREATING THE PIPELINE AND PURIFICATION WORKS

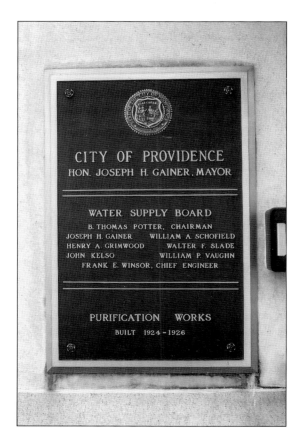

Mayor Joseph H. Gainer was the mayor of Providence from the inception to the completion of the Scituate Reservoir Project. Therefore, his name is inscribed on this plaque that is located beside the side door to the Water Purification Works building. In 1969, the building was reconstructed and rededicated to Philip J. Holton, the former chief engineer. (Author's collection.)

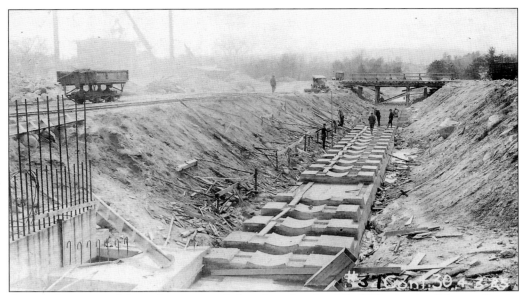

As seen from east of the influent control chamber, this April 3, 1925, view is of the cradles for the 94-inch pipe that was built over the main drain. The trestle in the middle distance is to carry the contractor's railroad across the aqueduct line at the new East Road.

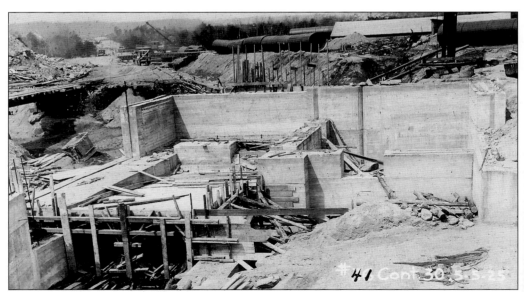

The foundation walls of the head house are taking shape on May 5, 1925. The water entered the head house and then was dispersed to the purification process. This view is looking west toward the new East Road. Sections of pipe are lined up on the embankment, ready to be laid on the trestles in the trench.

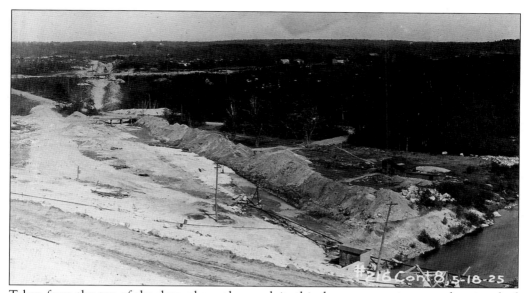

Taken from the top of the dam, above the conduit, this downstream view was photographed May 18, 1925. It shows the pipes from the conduit that will go to the filters. The access road that travels below the dam is to the left. Nursery Road crosses the pipeline on the first bridge, seen headed east. The second bridge in the top left area is the East Road Bridge.

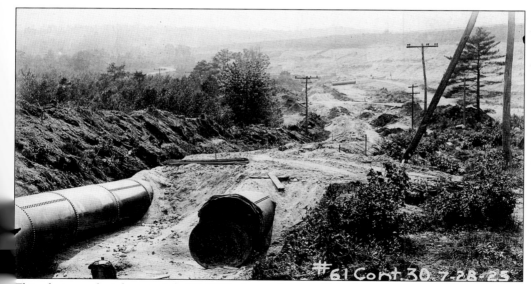

This photograph, taken on July 28, 1925, shows the two 60-inch pipelines, heading east to the junction chamber. The Gainer Dam can be seen at the top in the distance. The pipeline will travel from the dam about three-quarters of a mile to the purification plant.

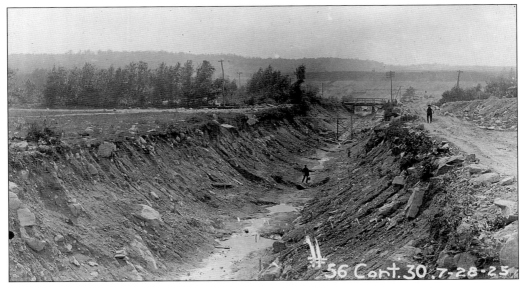

This excavation is for the 94-inch pipeline, looking west towards the junction chamber and the two 60-inch pipes. The bridge in the distance is Nursery Road, and further on is the Gainer Dam.

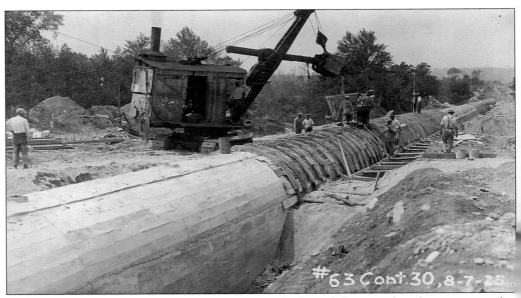

On August 7, 1925, the section of 90-inch pipe, in the lower left corner, has the concrete jacket in place. The next section headed west is formed, and men are pouring concrete. The further section of pipe is exposed, waiting for the workers to approach.

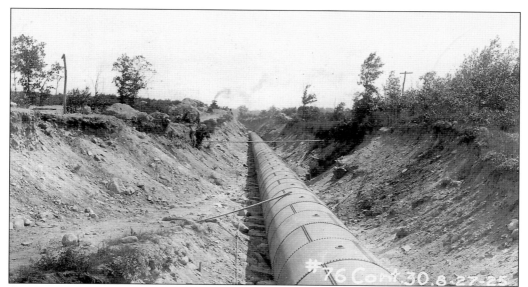

On August 27, 1925, the pipeline is heading east to the purification plant. It is resting on the concrete cradles, but the concrete jacket has not yet been poured. Lewellyn Yeaw's heirs had owned this 44.5-acre parcel that it cuts through.

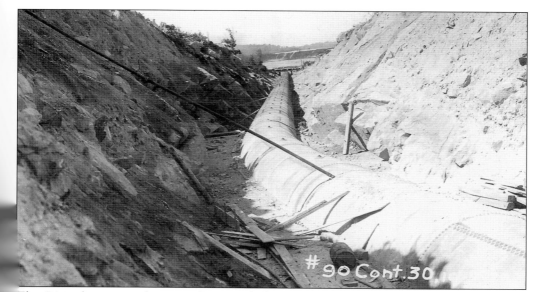

The 94-inch pipe angles easterly toward the new East Road on October 3, 1925. This photograph is looking west toward the dam. The concrete anchor can be seen running along the base of the pipe.

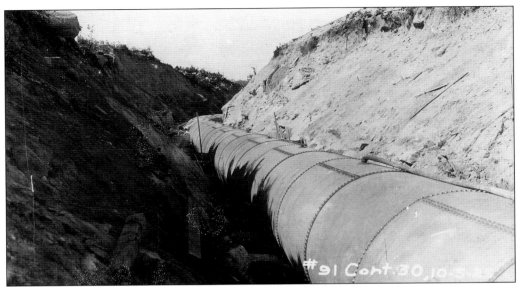

This photograph shows the 94-inch pipe passing through the deep cut near the angle. The concrete cradles can be seen and the end of the concrete anchor at the angle. This is looking westerly.

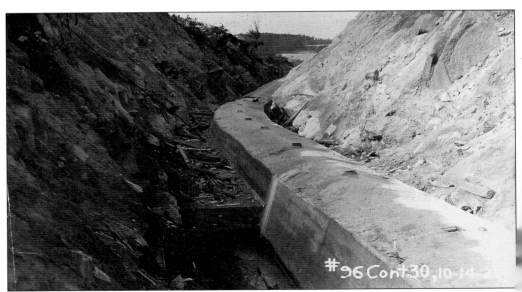

By October 14, 1925, the concrete jacket has been installed over the 94-inch pipe through this cut. The next step in the process will be to back fill over the pipe. The construction of this pipeline was awarded to Winston and Company of Kingston, New York, on May 22, 1924.

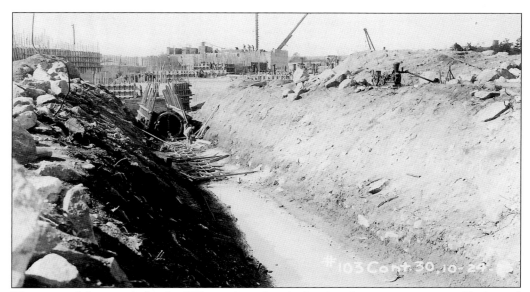

This view of the trench for the Effluent Aqueduct is showing the concrete support blocks and aqueduct forms. This photograph, taken on October 24, 1925, is looking west. The head house and main structure can be seen in the background.

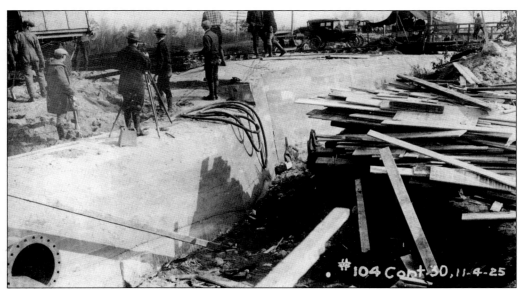

This photograph, taken on November 4, 1925, is showing the Y connection between the 60-inch and the 94-inch steel pipes. The concrete jacket is in place, and this photograph is looking northeast. The tent in the background is sheltering the plant for mixing mortar for the mortar gun. It was used for a short time in lining the 94-inch pipe.

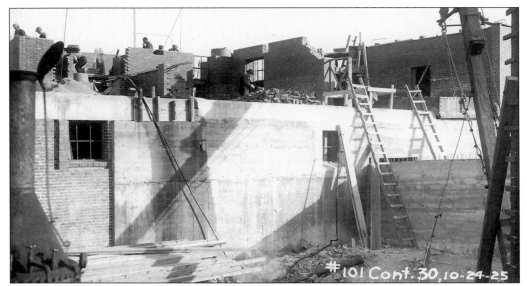

On October 24, 1925, this photograph shows that the west foundation walls of the head house are in place and the brickwork has begun. The pipe gallery to the influent control chamber is on the right. The following verse is from "If I Could Go Back" by Helen O. Larson: "A reservoir had to be made, folks had to have clean water to drink / The heartache that it would cause, didn't they stop to think."

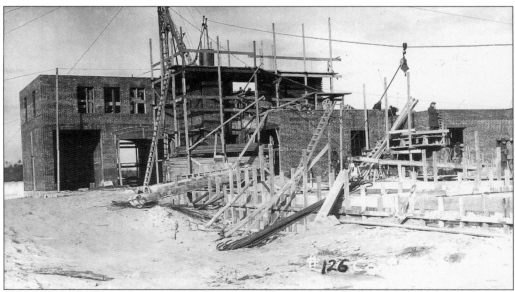

This is the south and west sides of the head house on December 11, 1925. The roof of the main structure is in the foreground. Being the month of Christmas, the following verses are from "Upon the Christmas Tree" by Helen O. Larson: "If you have children let them have a merry Christmas day / For soon they'll be grown, married and moved away. So as I watch the snow flakes silently coming down / So lightly floating as they touch the ground. Tears fill my eyes so I can hardly see / As the snow flakes fall upon the Christmas tree."

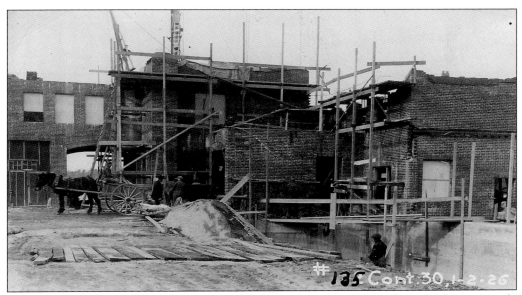

This photograph was taken January 2, 1926. It shows they are still using horse and wagon to do some of their chores. This is the east side of the head house. The staging is in place, as the brick work progresses.

This photograph moves along to January 11, 1926, showing the brick work for the service water room and line house. It appears they have had a snow storm recently, but work goes on. This view is looking north from south of the main structure.

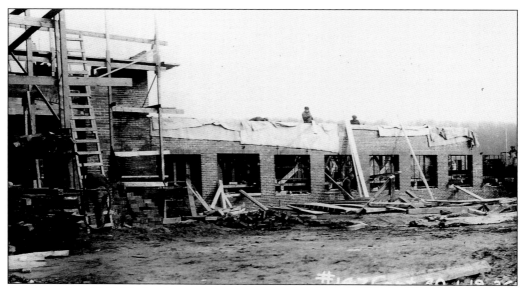

On November 10, 1925, they began storing water in the reservoir. On September 30, 1926, this purification plant began operation. On January 19, 1926, the south wall of the service water room began to take shape. This is looking north.

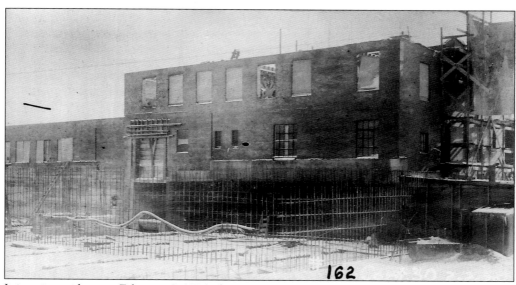

It is quite evident on February 3, 1926, that construction is moving at a fast pace in the middle of winter. The north and west walls of the head house are visible in this photograph, while the second floor is clearly taking form.

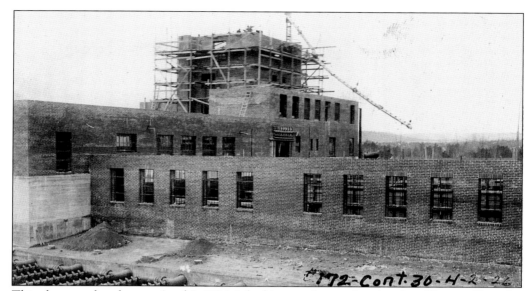

This photograph, taken on April 2, 1926, is looking southwest, showing the effluent gallery, the line house, and the service water room. The head house structure is complete, and the tower is up to the fourth floor.

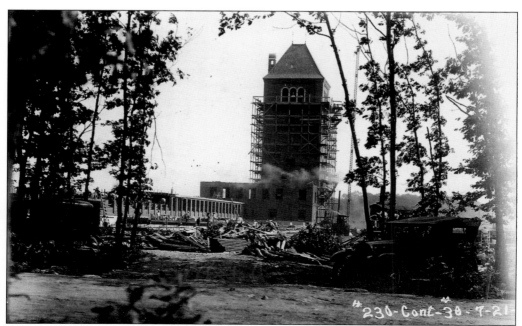

Looking south from the north access road shows the central gallery about half completed on July 21, 1926. It appears the tower is complete, and they have started to dismantle the staging.

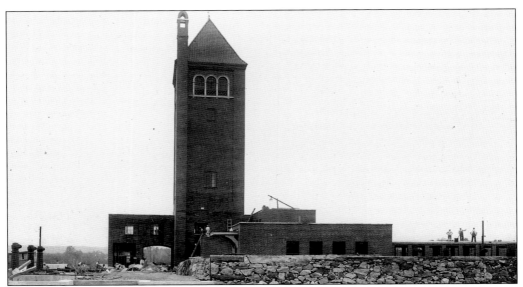

This is looking west from the back of the main structure on August 24, 1926. It shows the east elevation of the line house, the effluent gallery on the right, and the record room. The tower is complete, and operation will begin in less than three months.

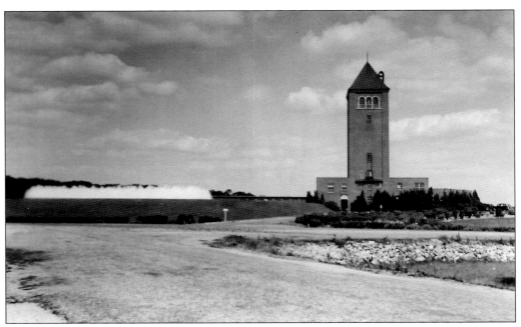

Taken on June 26, 1936, this is a general view of the Water Purification Works. It had been in operation for almost 10 years. The road in front of it is Route 116, and the road in the foreground is the access road that travels to the base of the dam on its way to the roadway on top of it.

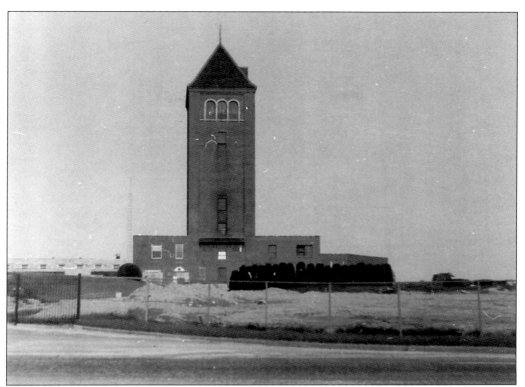

This photograph was taken in the early 1960s. It shows a fence has been installed around the entire Water Purification Works. There is a gate to the left but it was always left open. Tours used to be announced in the paper and conducted for the general public. (Author's collection.)

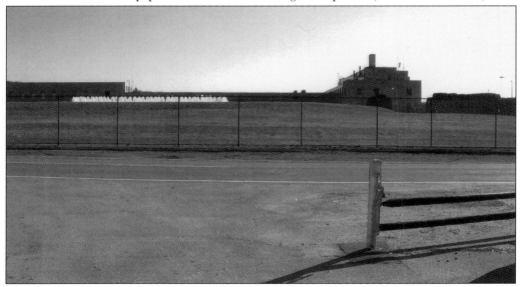

April 11, 2010, is when this photograph was taken. It shows the main structure has been torn down and replaced with the one pictured. The entrance has been relocated to the right, and the gates are now closed with closed-circuit television. (Author's collection.)

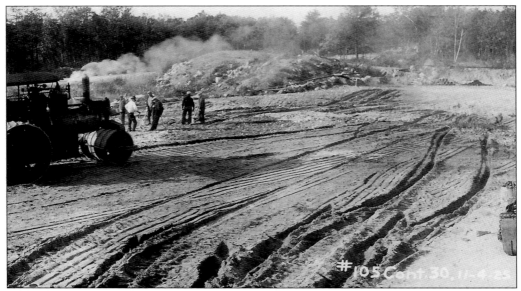

This photograph was taken on November 4, 1925. It shows the embankment under where the influent aerator will be placed. The ground is being prepared and rolled. East Road (Route 116) can be seen in the background, running behind the stock pile of earth.

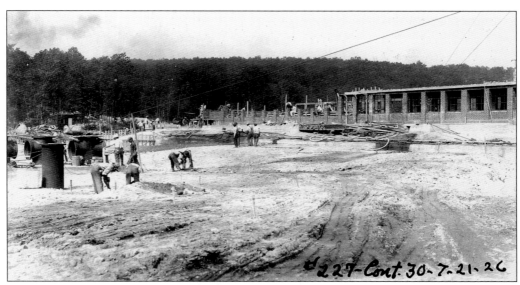

This is looking northeast from near the influent control chamber on July 21, 1926. The embankment of the influent aerator is in the foreground and is nearly complete. The tops of filters and the control gallery on the west bank are beyond the influent aerator. Workers are laying bricks on the north end of the central gallery.

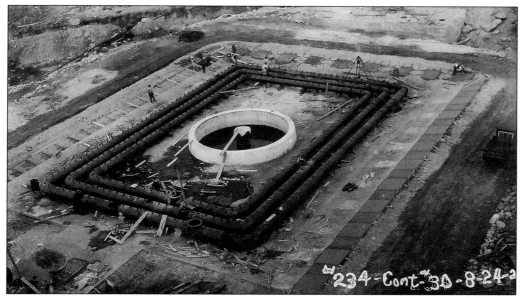

The influent aerator has really taken shape by August 24, 1926. This view is from the tower of the head house. The concrete apron is nearly complete. It will be working in less than three months.

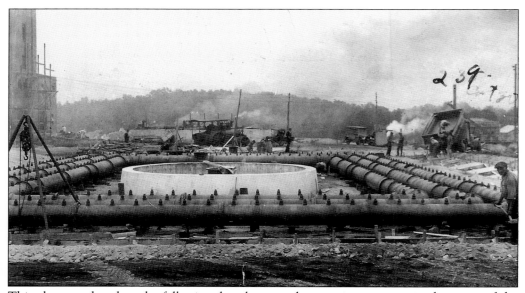

This photograph, taken the following day, shows workers casting concrete in the apron of the Influent Aerator. There appears to be more horse-powered vehicles and fewer horse-drawn wagons as time marches on. This view is looking south.

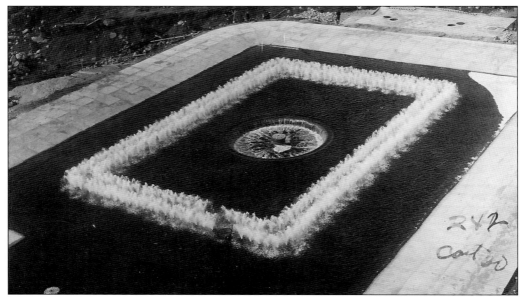

The completed influent aerator and sand bins are being tested on October 11, 1926. This photograph again was taken from the tower of the head house. In one month, it will be set into operation on a permanent basis.

This photograph was taken in January 2010. It was taken from the silo at the north end of the property. It shows the influent aerator working full time, 24 hours a day. To the left is the new Water Purification Works building. To the far right is the now Route 116 and the new gated entrance. All the land that can be seen in this photograph belonged to Hannah M. and Harden I. Fiske. Located both sides of Route 116, the land was their 179.49-acre farm. (Author's collection.)

Eight

CREATING THE
TUNNEL AND AQUEDUCT

A little to the left of the center of this January 2010 photograph, the cut in the tree line can barely be seen. This is looking at approximately where the tunnel begins its 3.5-mile journey to Cranston. Then the 1-mile cut and cover aqueduct could continue to carry the water the balance of the way to terminate at the siphon chamber. Plans were filed with the Town of Scituate and the City of Cranston on April 4, 1917. (Author's collection.)

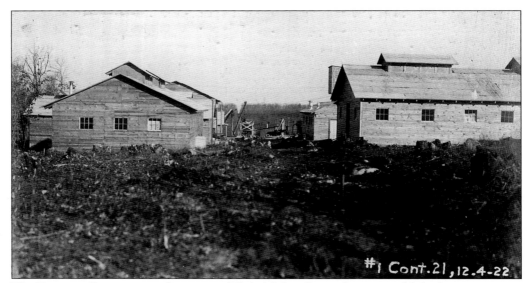

The Keystone Construction Company of Philadelphia, Pennsylvania, established a construction camp that consisted of 21 various buildings. This photograph, taken on December 4, 1922, shows the west end of camp where the bunkhouses were located. The maximum population was 89 men, 6 women, and 10 children. This camp was located about 1.5 miles southeast of Scituate Avenue and west of Pippin Orchard Road in Cranston. This camp was set up on September 22, 1922.

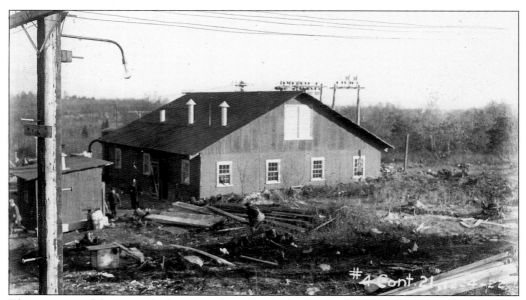

This is a view of the camp, looking west from the shaft office building on the right. The foreman's house is behind it, and the superintendent's house is on left behind the water tower. The central heating plant is in the left foreground. Excavation of the shaft began on September 25, 1922.

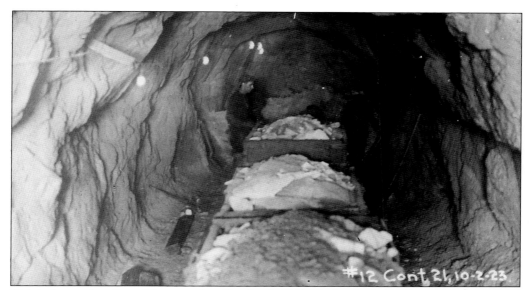

This is the east heading of the tunnel on October 2, 1923. Muck is loaded by hand in the muck cars in the foreground. The muck pile and the face of the heading can be seen in the background. Because it took so long to send the cars out to the entrance in Scituate and wait for empty cars to return, it was decided to drive a shaft down in Cranston to cut the distance and time involved.

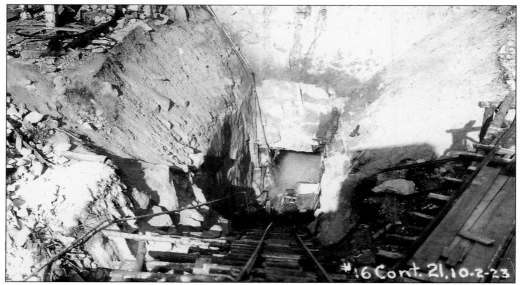

Excavation of the shaft began on September 25, 1922, and at 27 feet they struck solid rock. Rock excavation began on October 24, 1922, and continued without interruption until the bottom of the 140-foot shaft was reached on December 9, 1922. The rock was loaded in mine-type cars and drawn by battery-operated mining locomotives to the shaft and then raised to the surface.

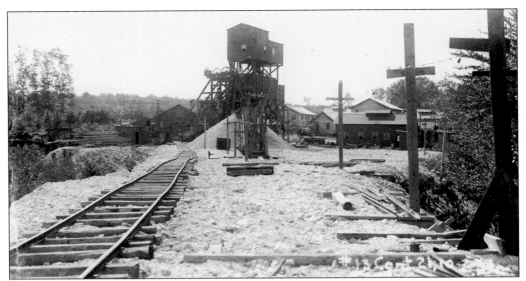

As the rock came to the surface, it was dumped into a gyratory crusher and sent to the screening plant, which was where it was processed into concrete aggregate. This procedure continued until October 18, 1924, when it was decided they had enough stock piled to complete the job of lining the tunnel with concrete. This photograph shows the crushing and screening plant on October 2, 1923. The blacksmith shop is on the right, and the compressor house is on the left.

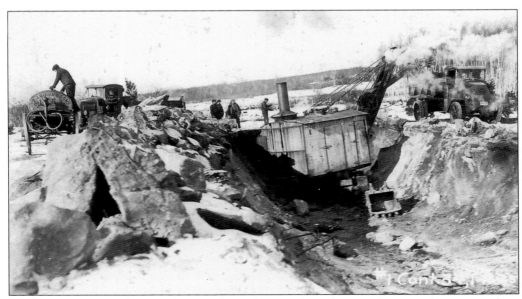

While one crew is working on the tunnel, another crew is working on the cut and cover aqueduct. Looking west, this photograph was taken on January 15, 1925. Across the top of the shovel reads, "Erie Shovel and Ball Engine Company." Also notice that F. J. Quinn and Son is delivering water.

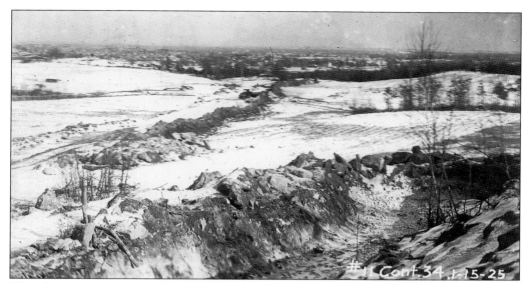

This photograph, taken on January 15, 1925, is looking east in the direction of Garden City, Cranston. It is showing the aqueduct trench and the access road fill. It also gives a good view of the terrain of the land. It appears there had been a snowstorm recently.

This photograph, taken on February 14, 1925, shows the meeting of the west portal tunnel and the tunnel headed west from the shaft in Cranston. This picture is looking east towards the shaft tunnel. The method of operation was to drill, blast, and remove the rock during a single work shift. However, in April 1924, they began employing two shifts, one drilling and blasting and the other removing the rock. On October 31, 1924, the heading east of the shaft holed through to the shaft tunnel.

This photograph of the Scituate tunnel was taken on February 17, 1925. It is looking west, showing the finished arch and sidewalls. Steel forms are still in place in the background. Work began on the westerly end of the tunnel on June 6, 1923, and the easterly end on June 1. The installation of the tunnel's concrete lining began on November 6, 1924, and was completed on August 19, 1925.

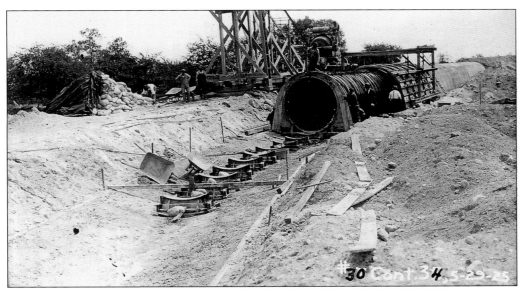

The Scituate aqueduct extended from the Scituate tunnel to the siphon chamber. It consisted of about a mile of 90-inch concrete aqueduct, constructed by Cenedella and Company of Milford, Massachusetts. This view looking west was taken on May 29, 1925. The construction procedure was as follows: pour the concrete blanket, lay the pedestal blocks in it to support the pipe, then place reinforcing steel around the outside and attach the forms together to be ready to receive the concrete that would totally encase the pipe.

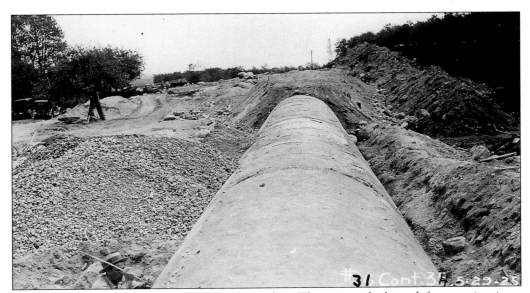

This view is looking east from on top of the aqueduct. The man in the lower left corner is using a rod to plug the tie rod holes. A work force of 22 laborers and a foreman installed the forms, placed the reinforcing, and poured a 30-foot length of aqueduct in approximately 4.5 hours.

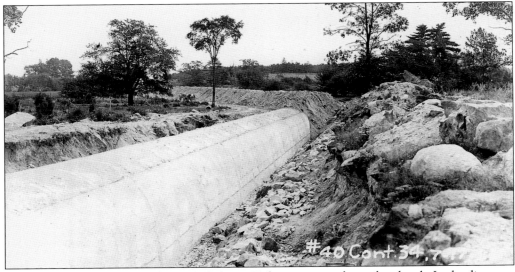

This photograph, taken on July 17, 1925, shows 30-foot sections of completed arch. In the distance, the fill is being placed to cover it. The first section of the aqueduct was installed on May 5, 1925, and for a period of 105 consecutive days, an average of 27.1 feet was completed each day.

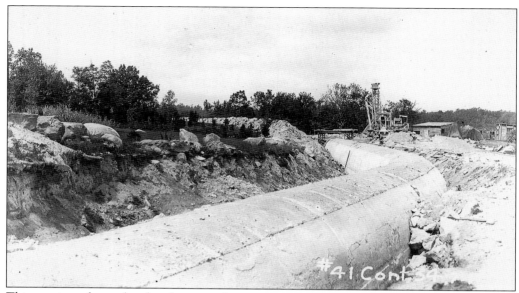

This portion of completed arch is rounding a curve on its way to the siphon chamber. In the distance can be seen the structure for the half-cubic-yard mixer. Dry cement was delivered to the mixer from a nearby storage building. This allowed concrete to be made in the general area. This view on July 17, 1925, is looking west.

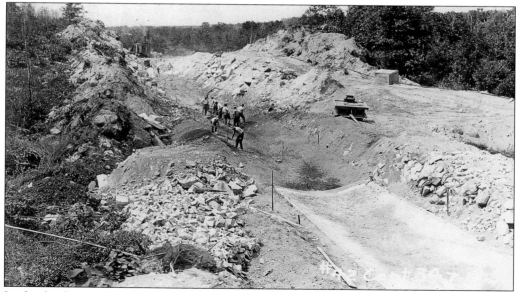

In the far distance can be seen a steam shovel excavating the cut. In the center is a group of workers busy dressing the trench. Excavation for the aqueduct began on December 11, 1924, and a 3-inch blanket of concrete was installed for its foundation, as shown on the right.

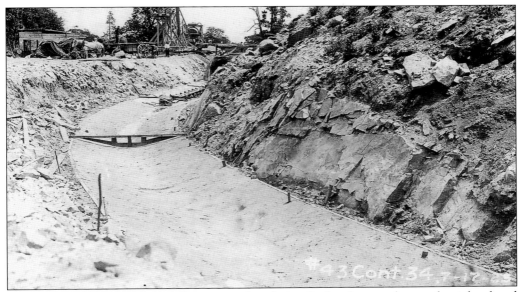

This photograph shows the 3-inch concrete foundation. It also shows stakes on the right placed on chords of 15 feet and located at joints in the outside forms. Around the curve looking east are the pedestal blocks for supporting the aqueduct sections. On top of the embankment, near the mixer, can be seen a horse and wagon still being used.

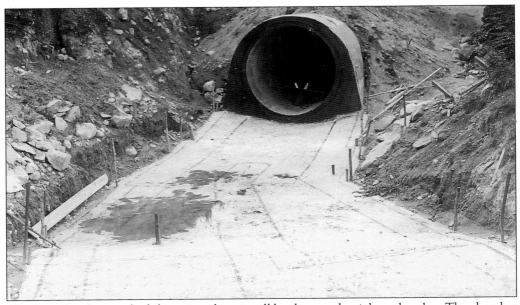

The Aqueduct has reached the point where it will hook up to the siphon chamber. The chamber superstructure has been marked on the foundation concrete with red paint. The O. D. Purington Company of Providence constructed this 10-by-10-foot, one-room building. It was completed on January 18, 1926, and on March 18, 1926, all work in connection with the cut and cover portion of the Scituate aqueduct was completed.

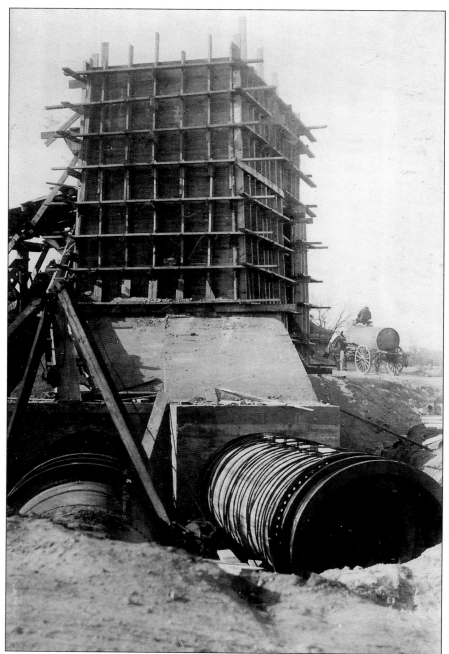

The 90-inch aqueduct enters the opposite side of this almost completed siphon chamber. This photograph, taken on December 18, 1925, shows the two 60-inch steel pipes leaving it. One will be headed to tie into the 42-inch main in Budlong Road, while the other will connect to the two 30-inch leading mains in Reservoir Avenue. On September 30, 1926, all connections had advanced sufficiently to permit water from the Scituate Water Supply to be introduced into the distribution system. On this date, the Pawtuxet River Supply, which had served the public since 1871, was abandoned.

Nine

CREATING A RESERVOIR

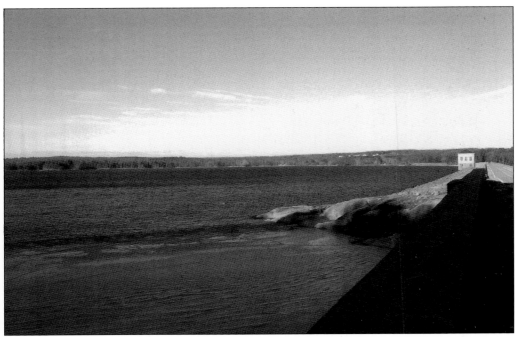

From April 26, 1915, when the Providence Water Supply Board was organized, to September 30, 1926, when water began flowing to Providence, the Town of Scituate would never be the same. The five mill villages of Rockland, Ashland, South Scituate, Richmond, and Kent were wiped off the map. In their place, the Scituate Reservoir System would eventually supply 60 percent of the inhabitants of the State of Rhode Island with an abundance of purified water. (Author's collection.)

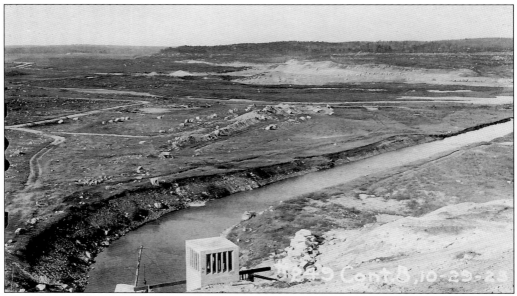

This photograph was taken on October 29, 1925, just two weeks before the reservoir would start to be filled. It is the last time all of this land would be seen. The village of Kent is to the right but out of view in this photograph. The Pawtuxet River can be seen in the distance flowing left to right, which was eventually diverted to flow through this channel.

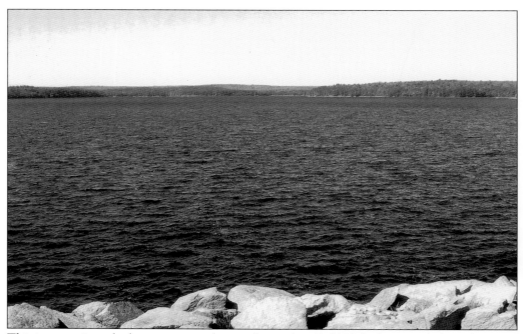

This is approximately the same view taken on September 19, 2009, looking north from the top of the dam. It clearly shows that the villages of Richmond and South Scituate are totally and forever submerged. Ashland and the Ashland Causeway are off to the top left. (Author's collection.)

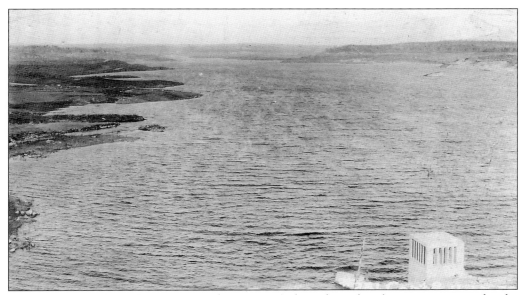

This photograph was taken on November 13, 1925, three days after the reservoir started to be filled. The intermediate intake is seen in the lower right corner. Most of the land is already covered by water, and the water is spreading toward the village of Ashland.

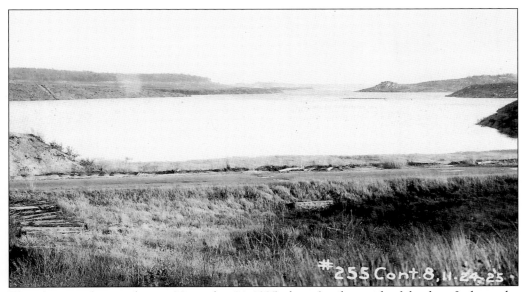

This photograph was taken on November 24, 1925, about 2 miles north of the dam. It shows the old abandoned Plainfield Pike that is about to be drowned by the rising water. Further north is the new Plainfield Pike crossing the Ashland Causeway on its way to where Rockland used to be. The following verse is from "The Land Was Condemned" by Helen O. Larson: "When the sun is setting and I'm all alone / My thoughts go drifting to my old Rockland home."

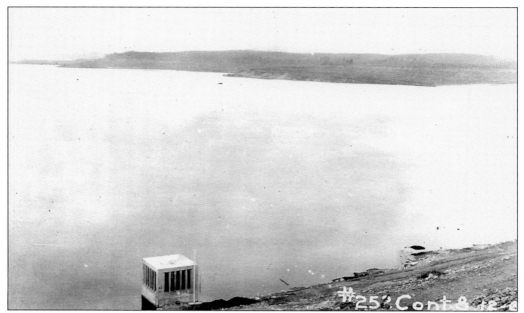

This photograph was taken on December 8, 1925, showing the water creeping up the intermediate intake. It also shows the reservoir claiming more shore land to eventually have a flow line of 38 miles. When it is filled to capacity, it has a water area of 3,632 acres.

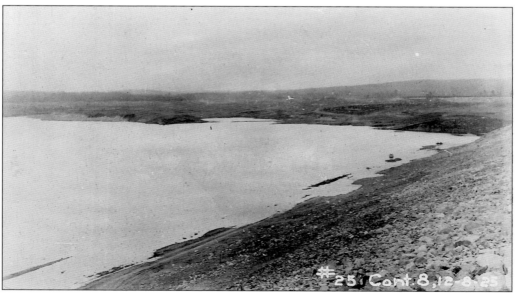

Taken on the same date, this photograph is looking to the right of the above photograph. Beneath the water lie the remains of the village of Kent. It was known as Kent Dam until October 15, 1949, when it was changed to the Gainer Memorial Dam. It happened in a ceremony honoring Joseph H. Gainer. He was the mayor of Providence from the time the reservoir was planned through the construction and completion of it.

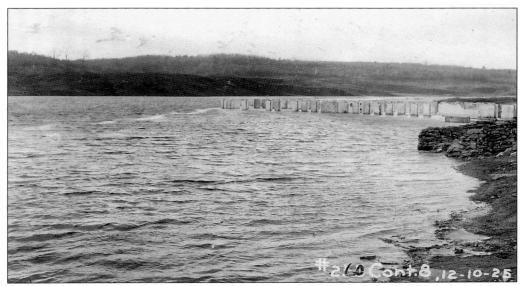

On December 10, 1925, the reservoir is gobbling up the remains of the foundation of the Richmond Mill. The Richmond Mill at one time was the world leader in the manufacture of corset laces and shoelaces. The following verse is from "Days of Destruction" by Helen O. Larson: "There were mills where people worked to get pay / Oh! The tears and heartbreak when they were destroyed one day."

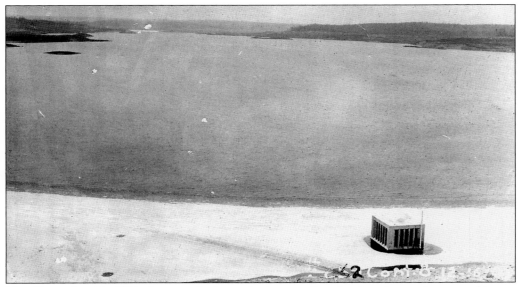

This December 16, 1925, photograph shows the intermediate intake reluctantly succumbing to the rising reservoir. The land on the left can be seen on the top of page 119. It is almost totally gone. The reservoir is slowly approaching the village of Richmond and will drown it beneath 57 feet of water.

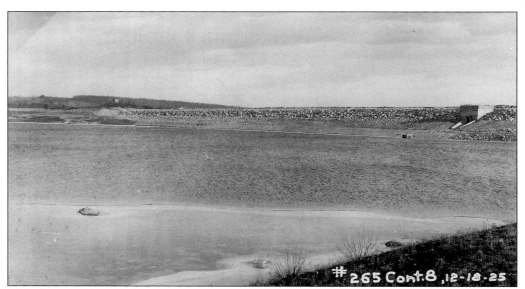

This photograph was taken on December 18, 1925, looking at the upstream face of the dam east of the gatehouse. Just above the end of the dam can be seen the top of the tower of the Purification Works. The dike continues from the end of the dam to the new East Road (Route 116).

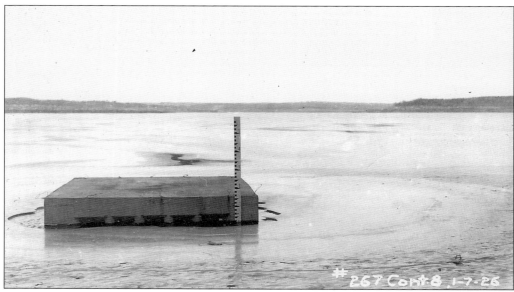

This view of the intermediate intake was taken on January 7, 1926, from on top of the riprap. The riprap was placed on the upstream face of the dam to prevent erosion from wave action. This can be viewed in the photograph above. The following verses are from "Dear Old House" by Helen O. Larson: "The family that lived there moved, it was condemned one day / To build a reservoir, we would hear the old folks say. One day they demolished it, and tears ran down my eyes / And the night they burned the lumber up, the flames lit up the skies."

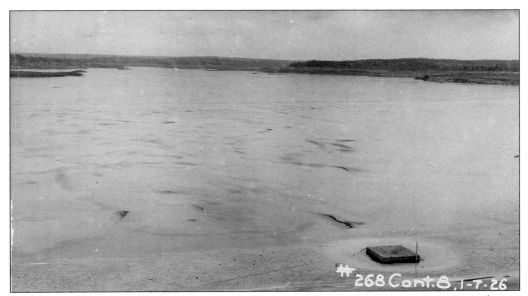

The intermediate intake is almost covered on January 7, 1926. The Pawtuxet River is no longer at this point. Fortunately, it is given new life when the reservoir spits it out from the conduit beneath the dam.

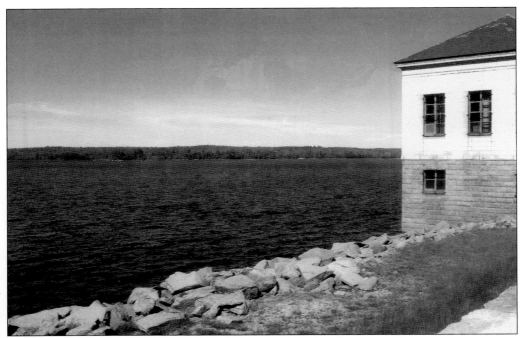

This photograph was taken from the top of the dam on September 19, 2009. It shows the top of the riprap looking north at a full reservoir. The following verse is from "My Hometown" by Helen O. Larson: "If I could go back, and visit my hometown / But it's an impossible dream, for all the buildings were torn down." (Author's collection.)

During this period, the Scituate Reservoir was built, the Pawtuxet River Supply abandoned, and the City of Warwick added to be serviced. Demand increased by 7.1 million gallons a day.

Between 1938 and 1951, East Smithfield Water was added, and demand increased 11.5 million gallons a day.

From 1952 to 1961, demand increased 7.4 million gallons a day, as Kent County Water was added.

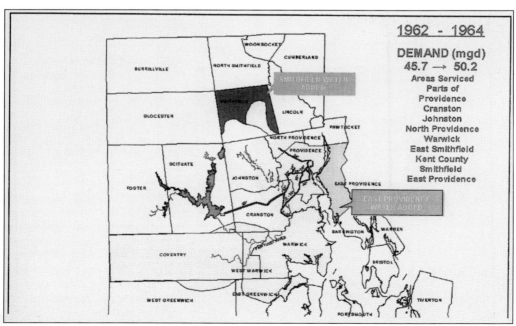

During the period from 1962 to 1964, demand increased 14.5 million gallons a day, as Smithfield Water and East Providence Water were added to the Scituate Reservoir System.

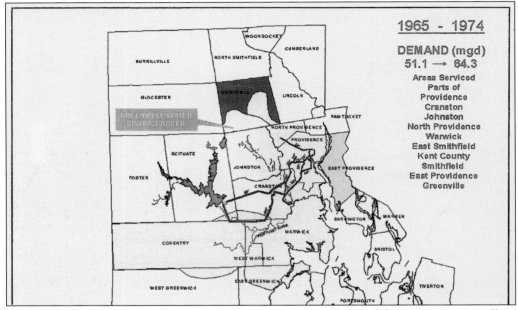

Between 1965 and 1974, the Greenville Water District was added, and demand rose 13.2 million gallons a day.

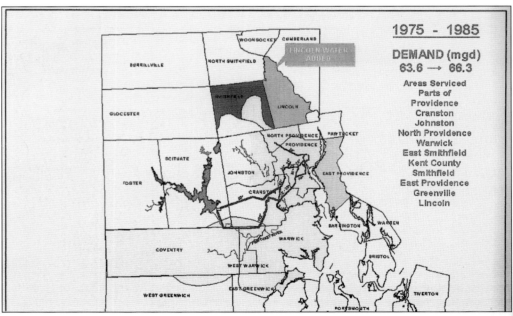

From 1975 to 1985, demand only increased by 2.7 million gallons a day, as Lincoln Water was added.

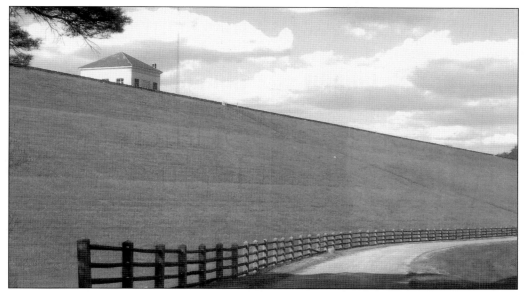

These two photographs show the Gainer Dam and the reservoir that annihilated five villages. The poem "The Villages" was written by Helen O. Larson at the age of 88: "One day a man from the city came to our village to say / They had bought all the buildings to be torn down and the lumber would be taken away. Oh! The heartache and sorrow when they heard him say / That they were going to lose their homes some day. Some of the people were crying they didn't know where to go / They had lived there all their lives and were heart broken that it was so. Soon the buildings were sold and the tearing down started too / And you could never know the pain unless it happened to you. One by one our neighbors moved away / Oh! When I think of that dreadful day. Oh! If only it hadn't happened and I was living there once more / Just to live in the same old house that I lived in before." (Author's collection.)

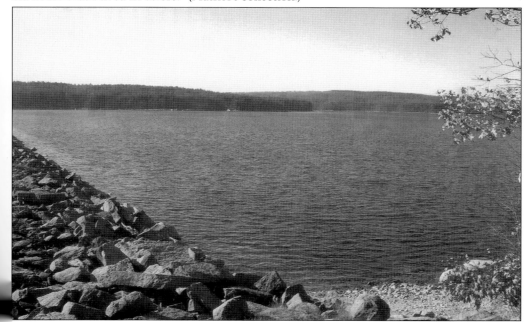

www.arcadiapublishing.com

Discover books about the town where you grew up, the cities where your friends and families live, the town where your parents met, or even that retirement spot you've been dreaming about. Our Web site provides history lovers with exclusive deals, advanced notification about new titles, e-mail alerts of author events, and much more.

MADE IN THE USA

Arcadia Publishing, the leading local history publisher in the United States, is committed to making history accessible and meaningful through publishing books that celebrate and preserve the heritage of America's people and places. Consistent with our mission to preserve history on a local level, this book was printed in South Carolina on American-made paper and manufactured entirely in the United States.

This book carries the accredited Forest Stewardship Council (FSC) label and is printed on 100 percent FSC-certified paper. Products carrying the FSC label are independently certified to assure consumers that they come from forests that are managed to meet the social, economic, and ecological needs of present and future generations.

FSC
Mixed Sources
Product group from well-managed forests and other controlled sources

Cert no. SW-COC-001530
www.fsc.org
© 1996 Forest Stewardship Council

Find Your Place in History.